IN THE LINE OF DUTY

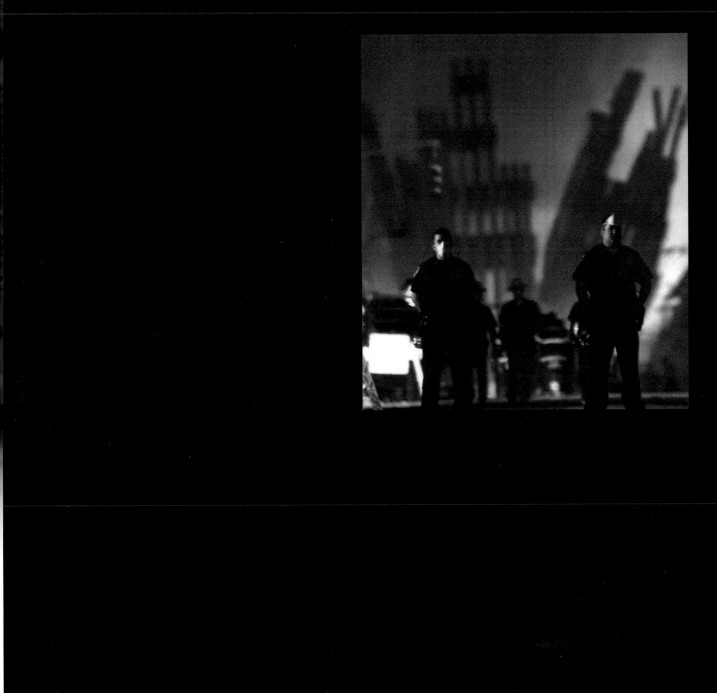

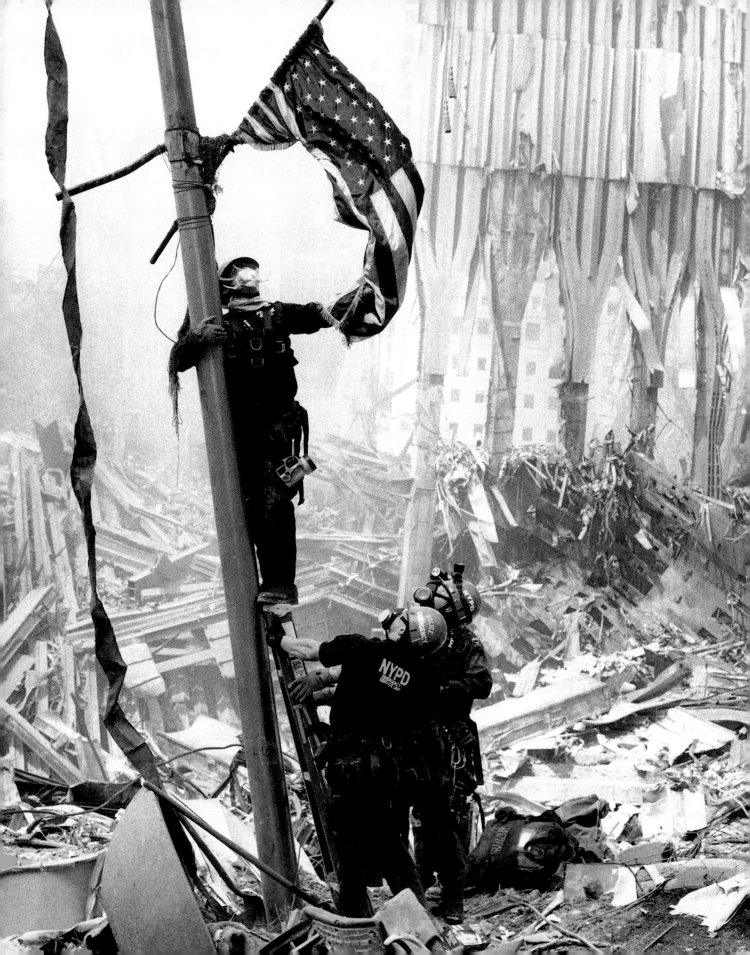

IN THE LINE OF DUTY

A Tribute to New York's Finest and Bravest

FOREWORDS BY

BERNARD B. KERIK
New York City's 40th Police Commissioner

AND

THOMAS VON ESSEN
New York City's 30th Fire Commissioner

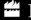 ReganBooks
An Imprint of HarperCollinsPublishers

Publisher's profits will be donated to the New York Police & Fire Widows' & Children's Benefit Fund

The New York Police & Fire Widows' & Children's Benefit Fund is
a nonprofit organization that assists the families of New York City
firefighters and police officers who have been killed in the line of
duty. Established in 1985 by Daniel J. "Rusty" Staub, who serves as
chairman, the fund provides benefits to families at the time of a death
to assist with immediate expenses. In addition, the fund distributes an
annual check to each of the surviving families.

The publisher's profits from the sale of this book will be donated to
this fund. Individual donations are also welcome and should be
addressed to:

New York Police & Fire Widows' & Children's Benefit Fund
P.O. Box 3713
Grand Central Station
New York, NY 10163

In their memory

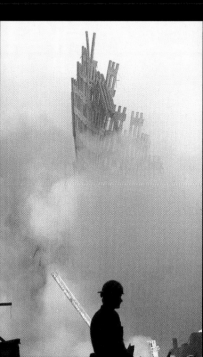

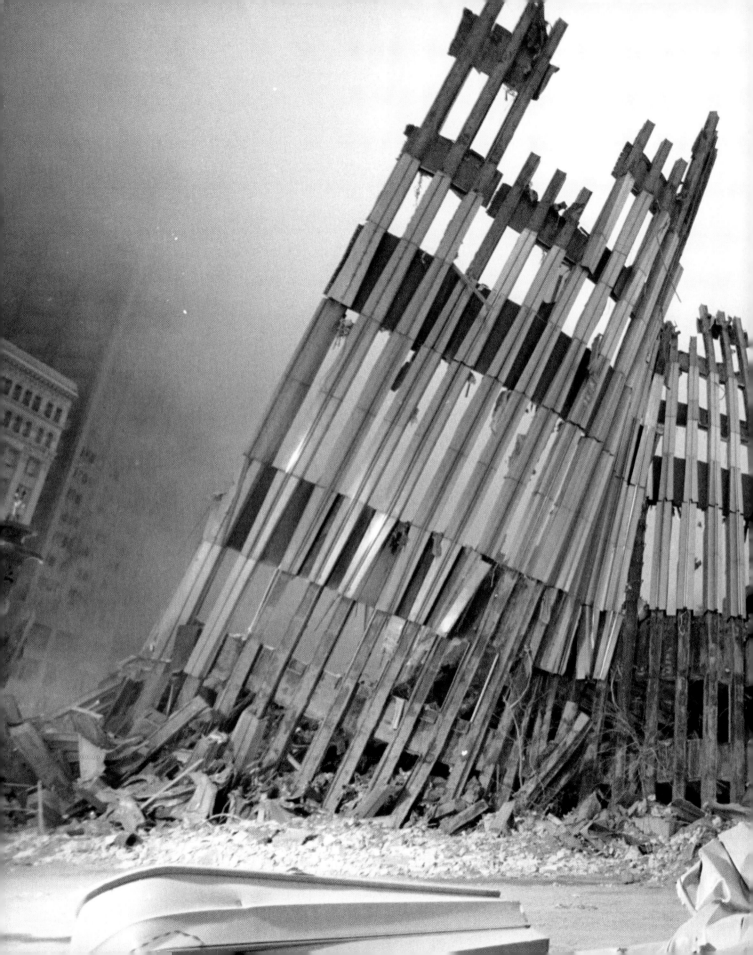

FOREWORD
BY BERNARD B. KERIK

On the morning of September 11, 2001, the city of New York and the United States of America were changed forever. Two hijacked airliners, loaded with innocent passengers, thundered toward the Twin Towers of the World Trade Center. At 8:48 A.M. the first plane hit, piercing the side of a one-hundred-ten-story building and the innocence of a nation virtually unblemished by the wars of history.

As the north tower burned and thousands were placed in peril, a gallant band of heroes moved into action. The survivors rushed out with panic and fear, but these heroes rushed in with courage and determination. With only the safety of others in mind, they raced through falling debris, past the

crushing tide of bodies, deliberately into the path of danger. When the second plane crashed overhead, and their minds switched from accident to attack, they continued on. When the first tower crumbled and buried their brother and sister officers, their firefighter friends, the civilians they came to save, they carried on. And when the final semblance of one of the world's most visible symbols of power and strength toppled into powder and smoke, taking with it twenty-three of their ranks, they continued on, digging and fighting until all hope of life was gone.

This book is dedicated to these heroes, to the twenty-three police officers who perished in an unimaginable attack on democracy and humanity, and to their comrades who desperately fought and struggled and bled and died in a noble effort to pull them and thousands of others back to safety. Theirs is a story beyond words; a story of bravery, fidelity, and sacrifice; a story that must never be forgotten.

Bernard B. Kerik,
40th Police Commissioner,
New York City

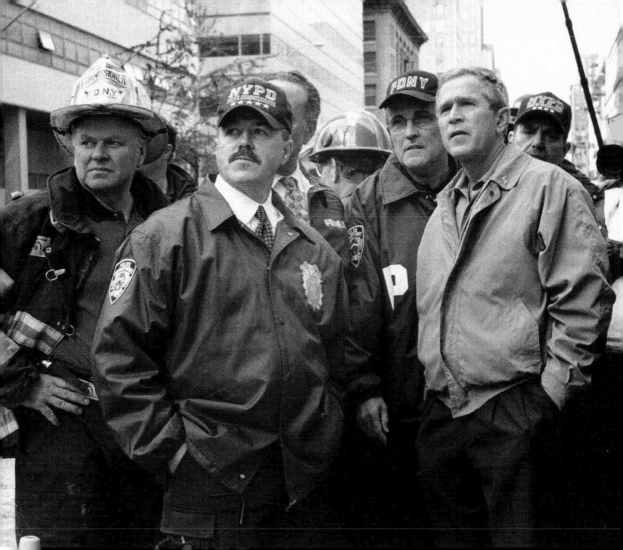

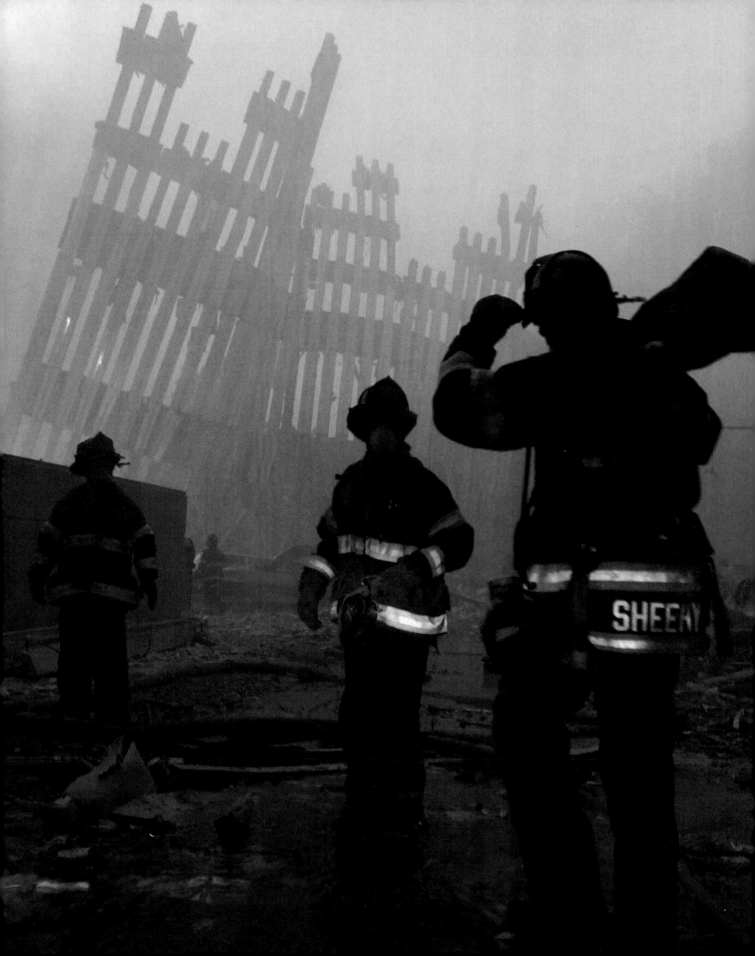

FOREWORD

BY THOMAS VON ESSEN

The Twin Towers stood tall, symbols of freedom, testaments to ingenuity, pillars of commerce. On a clear day they offered a crystal vision, capturing the most dynamic view of the most exciting city in the world. That morning couldn't have been clearer, but by noon our vision of life as we knew it was changed forever.

The terrorist attack that took place at the World Trade Center on September 11, 2001, is almost impossible to understand. The response to it is not. From every corner of this city firefighters, fire marshals, paramedics, emergency medical professionals, Port Authority police officers, New York City police officers, and hundreds of other rescuers rushed to the Trade Center. They carried out one of the largest and most effective rescues in history, safely guiding more than 25,000 people to safety.

Thousands who were evacuated reported that as they were coming down the building stairways, courageous firefighters were going up. These firefighters offered assistance to the injured; they swept through the floors making sure civilians

were out. After the towers collapsed, there were dramatic lifesaving rescues, though unfortunately not as many as we had hoped for.

In the end, we lost 343 members of the New York City Fire Department. Peter Ganci, our chief of department, who was lost while commanding the efforts at the Trade Center, once said, "In our department, no one is invincible; at all ranks we contribute and at all ranks we're vulnerable." Both our contributions and our vulnerabilities were evident on September 11. We lost members in every rank, from the first deputy commissioner with forty-two years on the job to probationary firefighters only a few weeks out of the academy.

All were members of a brotherhood, dedicated to preserving life. They handled their mission that day with grace, courage, and determination. They have gone on to be welcomed by the heroes who went before them and cherished by those they left behind. We vow to rebuild our department as their legacy. It is a pledge we make to them and a debt we gladly pay.

From the depths of this tragedy has come a greater sense of unity within our city and within our nation. The now-famous

image of three firefighters raising a flag over the wreckage of the World Trade Center will be an enduring symbol of that common purpose. It represents all that is right about America and pays tribute to the courage and bravery of those who pledge to serve.

Thomas Von Essen,
30th Fire Commissioner,
New York City

This is courage in a man: to bear

unflinchingly what heaven sends.

— Euripides

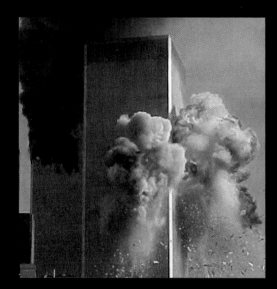

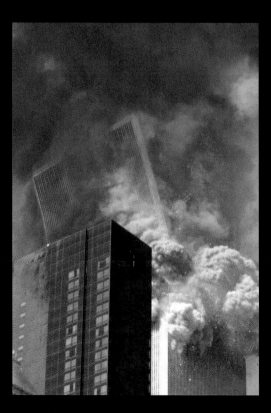

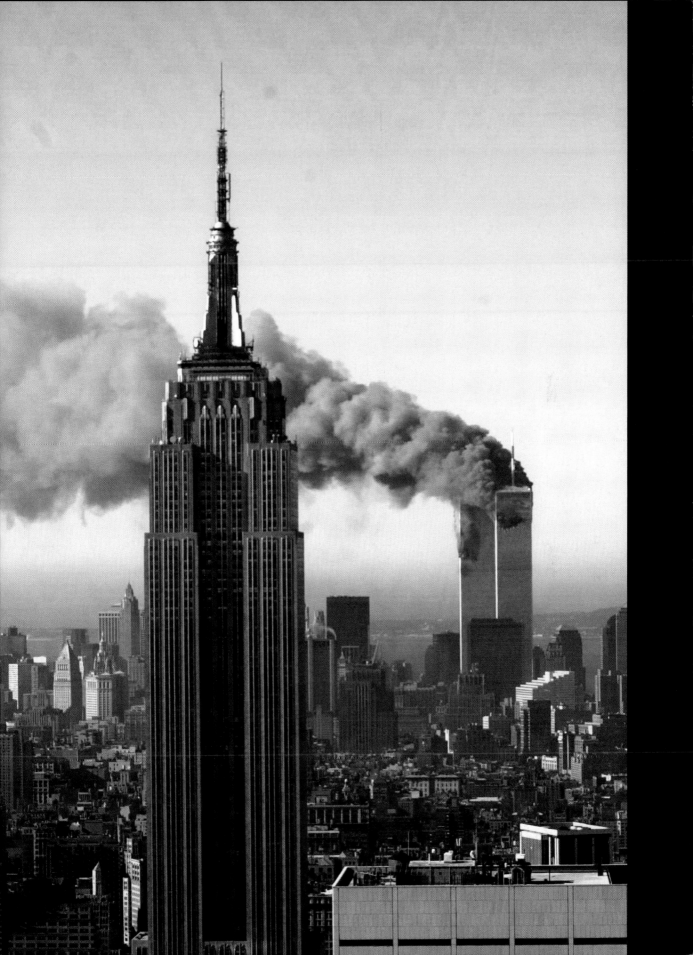

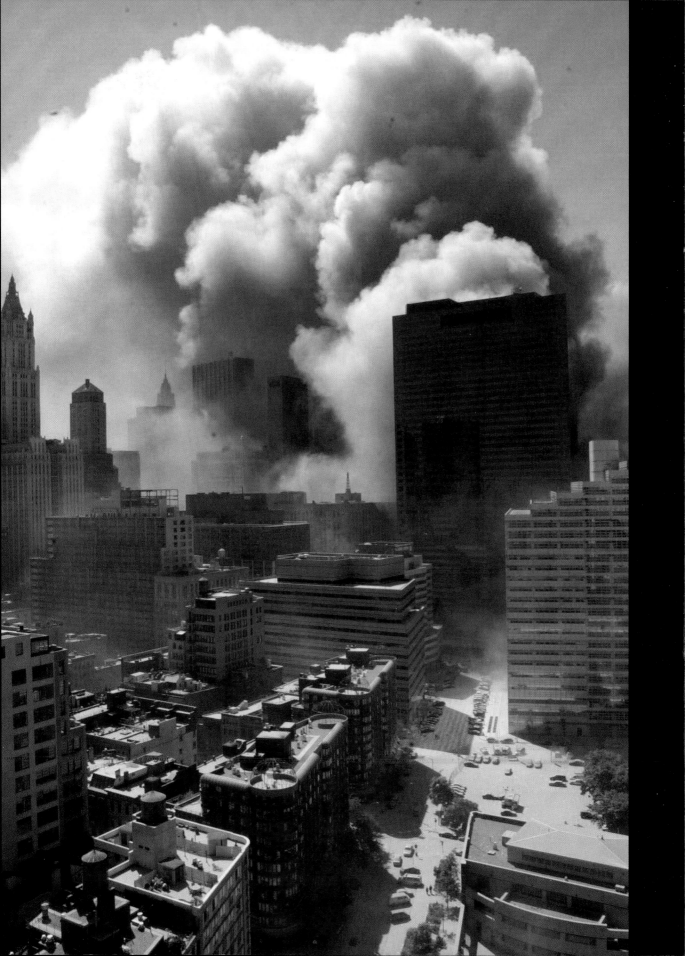

I DREAM'D in a dream, I saw a
city invincible to the attacks of the
whole of the rest of the earth;

.

Nothing was greater there than the
quality of robust love—it led the rest;
It was seen every hour in the actions
of the men of that city,
And in all their looks and words.

—Walt Whitman, "I Dream'd in a Dream"

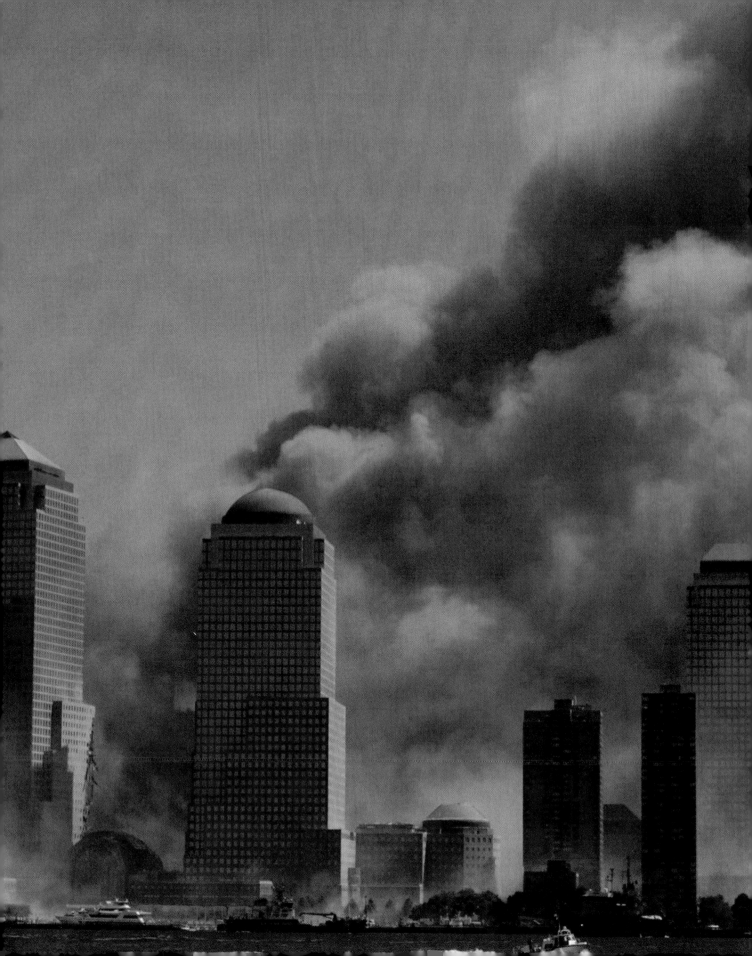

Terrorist attacks can shake the foundations of our biggest buildings, but they cannot touch the foundation of America. These acts shattered steel, but they cannot dent the steel of American resolve.

—President George W. Bush,
September 12, 2001

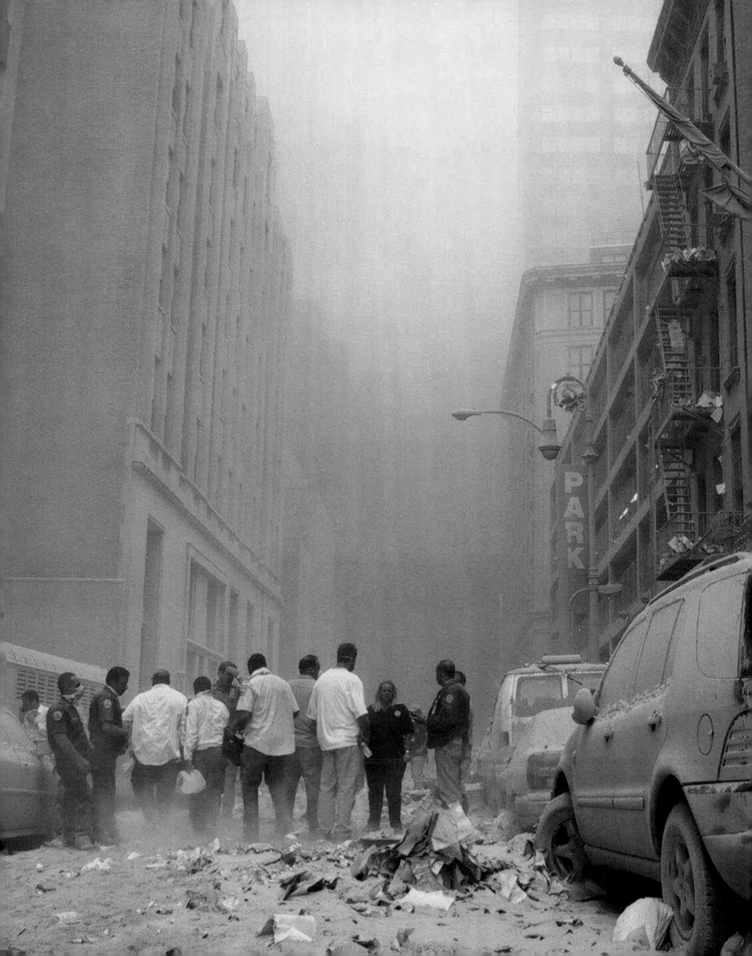

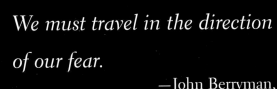

We *must travel in the direction*
of our fear.

—John Berryman,
"A Point of Age"

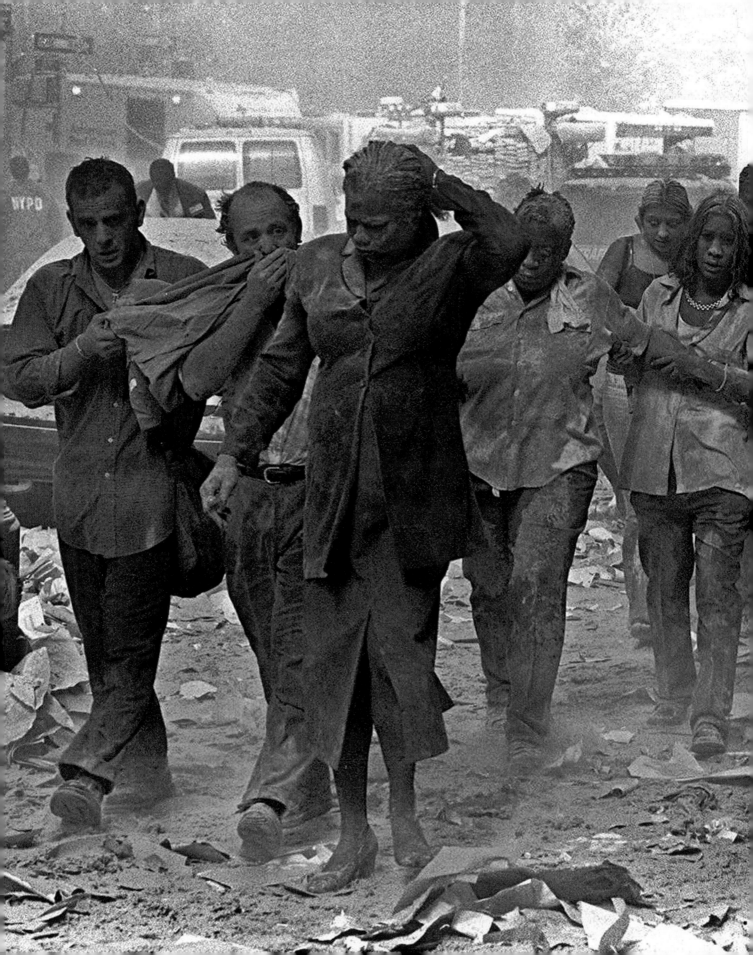

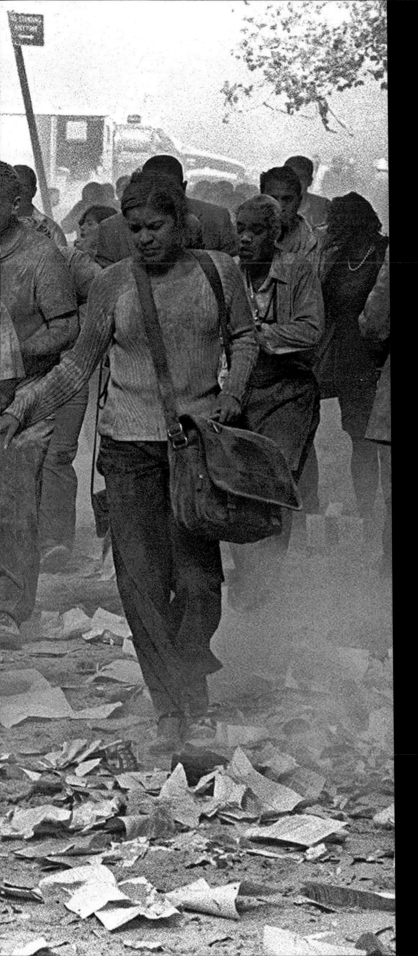

We can look at what shone in that day almost as brightly as the sun: the passenger heroism aboard the planes, the sacrifices of countless firefighters and policemen, the acts of dignity and courage that no one will ever truly know in the nightmare of the stricken building in the minutes before it collapsed. . . . It is at moments like this one that true heroism is born and leadership forged.

—Andrew Sullivan,
New York Times Magazine

23

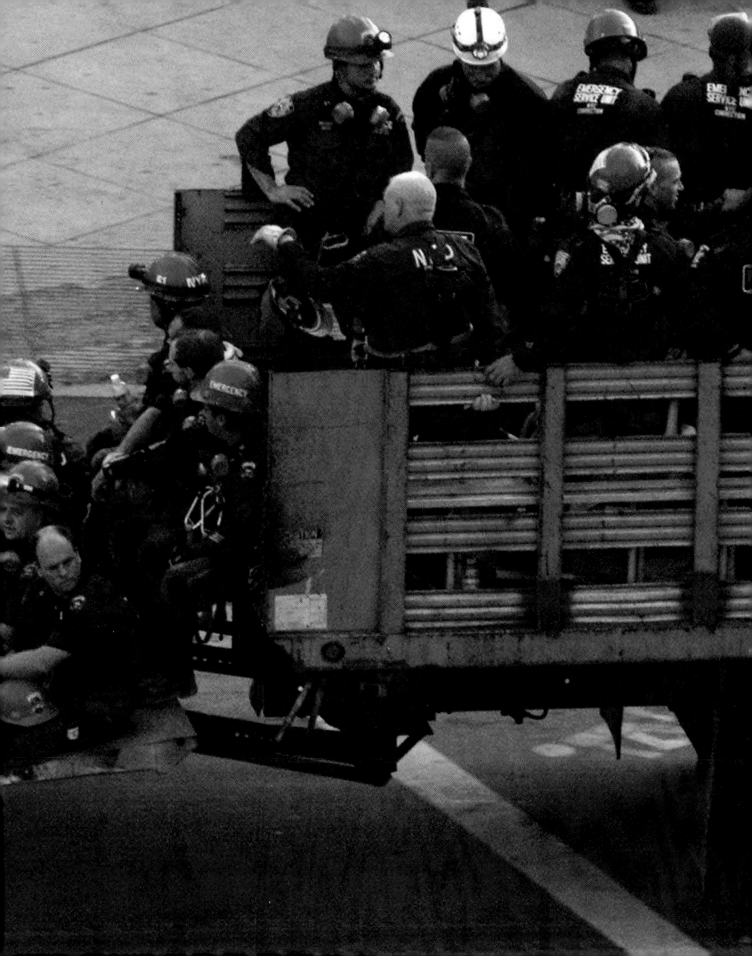

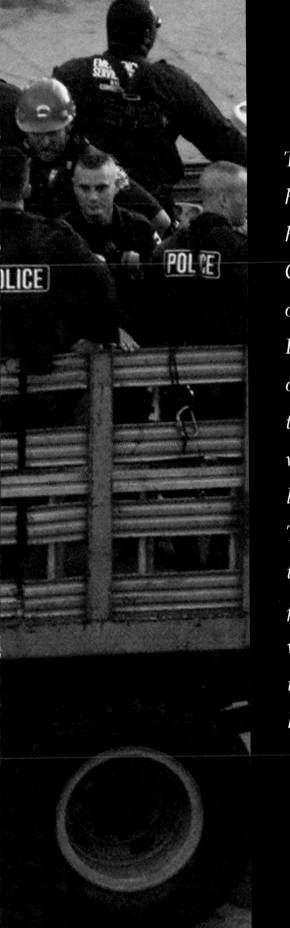

The Bible [John 15:13] says "Greater love hath no man than this, that a man lay down his life for his friends." Our brave New York City firefighters . . . New York City police officers . . . Port Authority police officers . . . EMS workers . . . health care workers . . . court officers . . . and uniformed service members— they laid down their lives for strangers. They were inspired by their sense of duty and their love for humanity. As they raced into the Twin Towers and the other buildings to save lives, they didn't stop to ask how rich or poor the person was, they didn't stop to ask what religion, what race, what nationality. They just raced in to save their fellow human beings. They are the best example of love that we have in our society.

—Mayor Rudolph Giuliani,
Citywide Prayer Service
at Yankee Stadium,
September 23, 2001

25

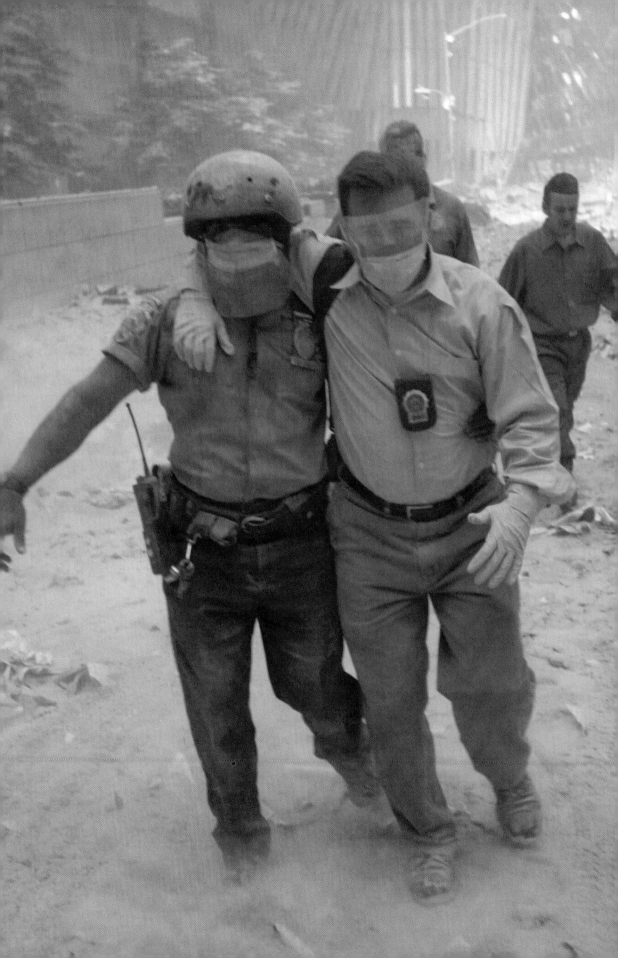

Such then is the character of true courage. . . . Though it never provokes danger, [it] is always ready to meet even death in an honorable cause.

—Aristotle

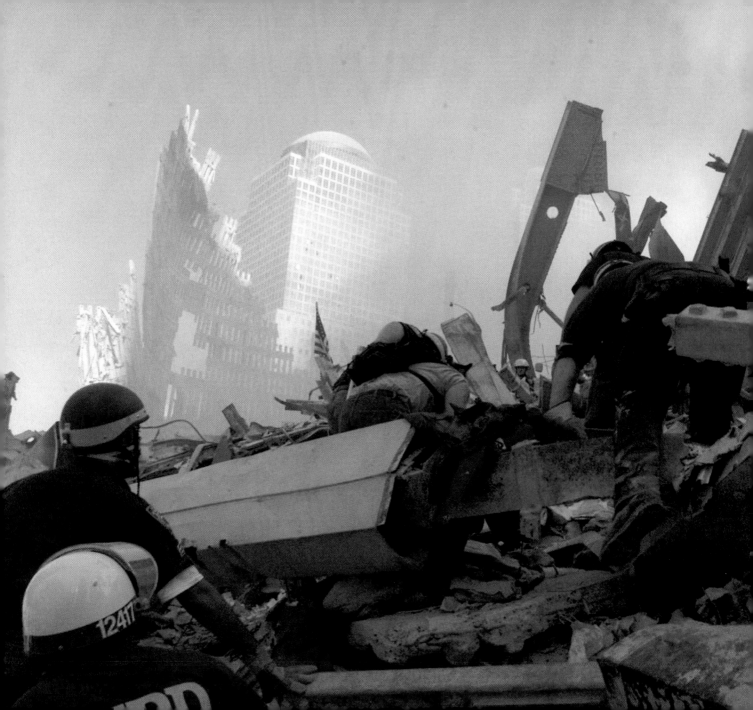

This week, we have seen genuine heroes. Most of them have familiar-looking but unfamous faces. Caked with ash, sweat, tears, and blood, they are the firefighters, police officers, ambulance workers, and emergency crews who rushed up the forbidding stairs of burning buildings when the World Trade Center and the Pentagon were pierced by airplanes and began to burn. While thousands of people tried to run from the blast to seek shelter and safety, they ran willingly into the fire and smoke and glass.

—Scott Simon,
National Public Radio,
September 15, 2001

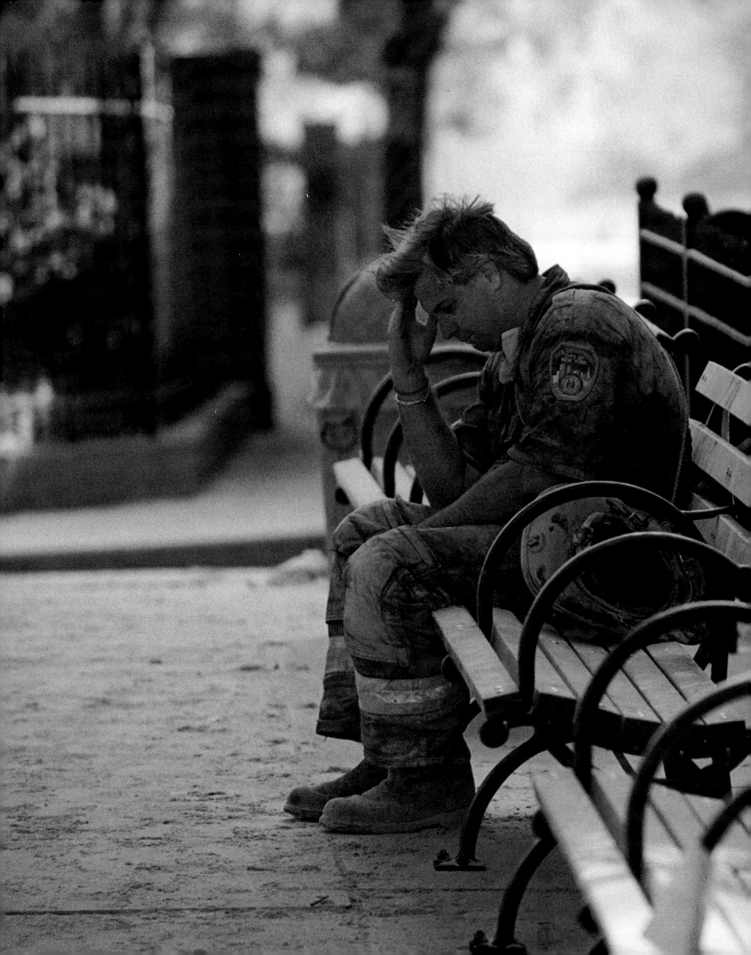

May God give courage to the survivors; may he sustain the rescue workers and the many volunteers who are presently making an enormous effort to cope with such an immense emergency. I ask you, dear brothers and sisters, to join me in prayer for them. Let us beg the Lord that the spiral of hatred and violence will not prevail.

—Pope John Paul II,
September 12, 2001

In New York City police are
called the "Finest" and firefighters
the "Bravest." That morning, they
showed why.

—*People,*
September 24, 2001

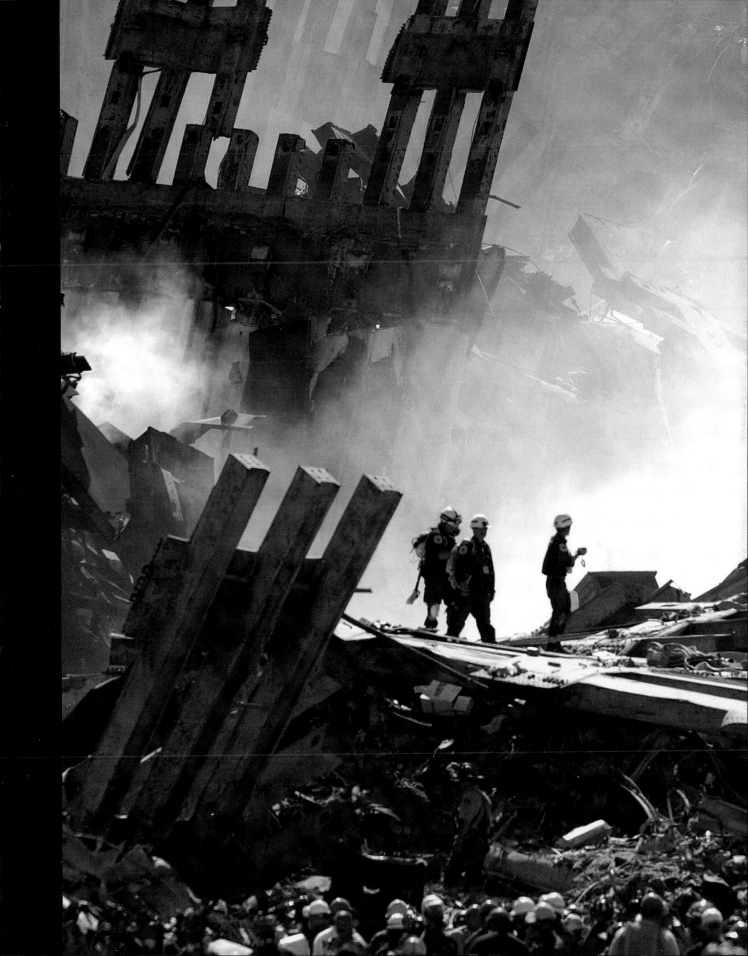

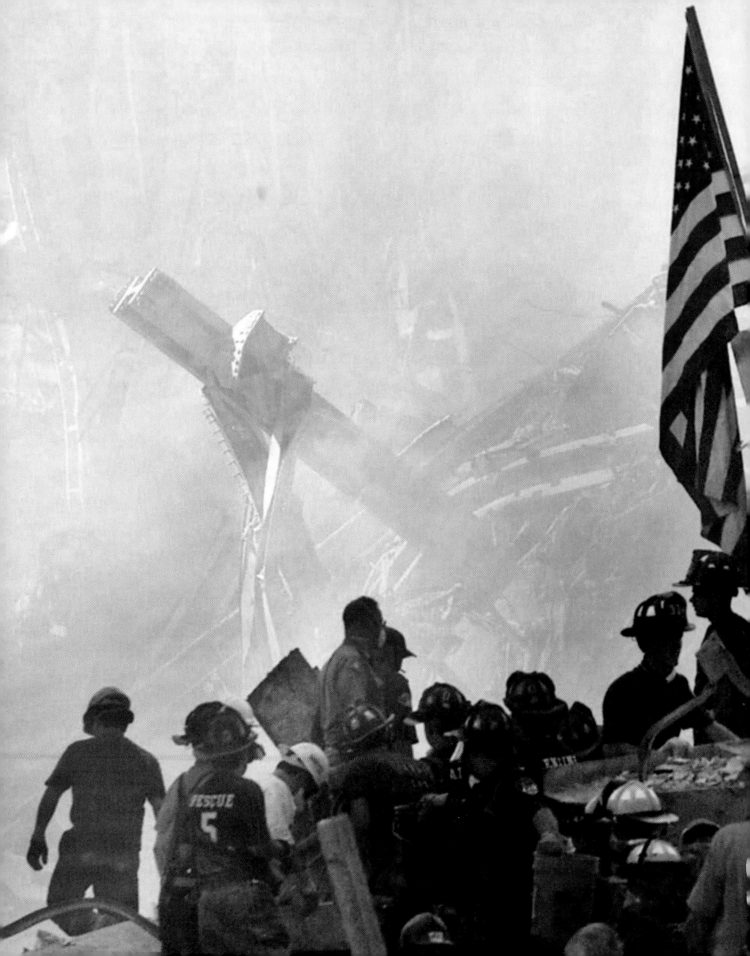

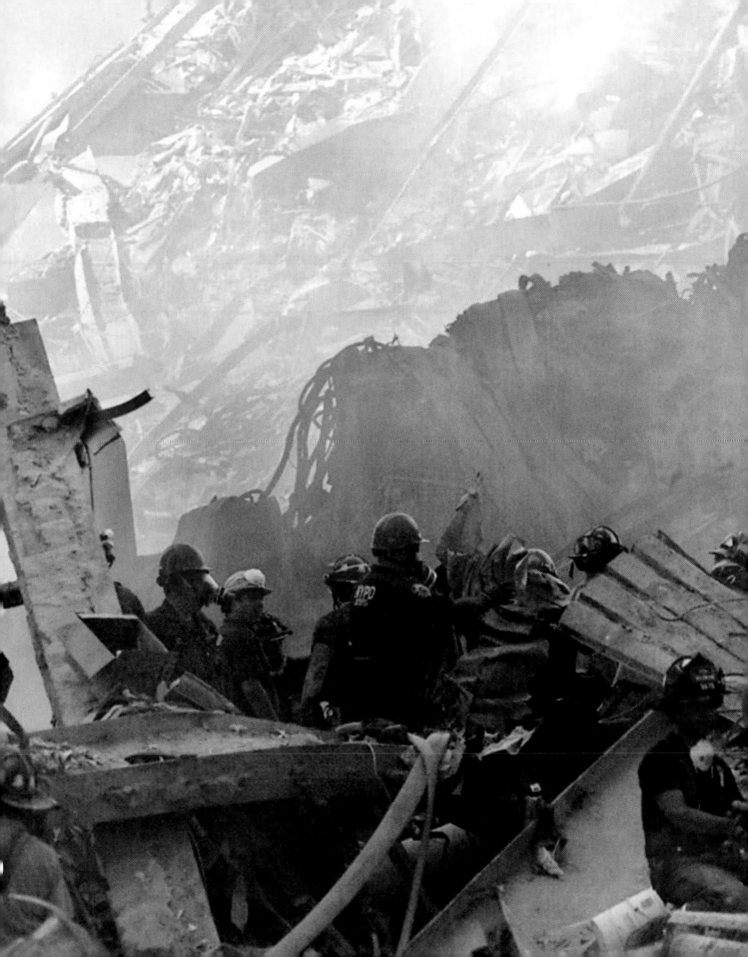

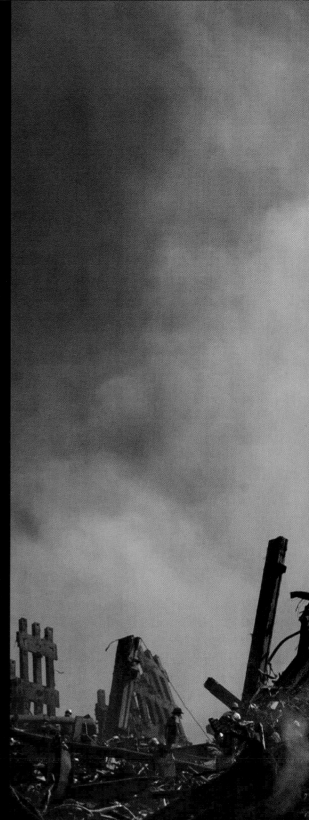

We've seen the extraordinary heroism
of our firefighters, police officers,
emergency service workers, and everyday
citizens. . . .

We owe a deep debt of gratitude for
the heroism of the thousands who have
been risking, and continue to risk, their
lives to help with the relief effort. . . .

This crisis has tested, and will
continue to test, the resolve and the
resilience of New Yorkers like never before.

But ultimately, the courageous and
resilient spirit of our people will prevail
over this cowardly act of hatred.

—Governor George E. Pataki,
September 13, 2001

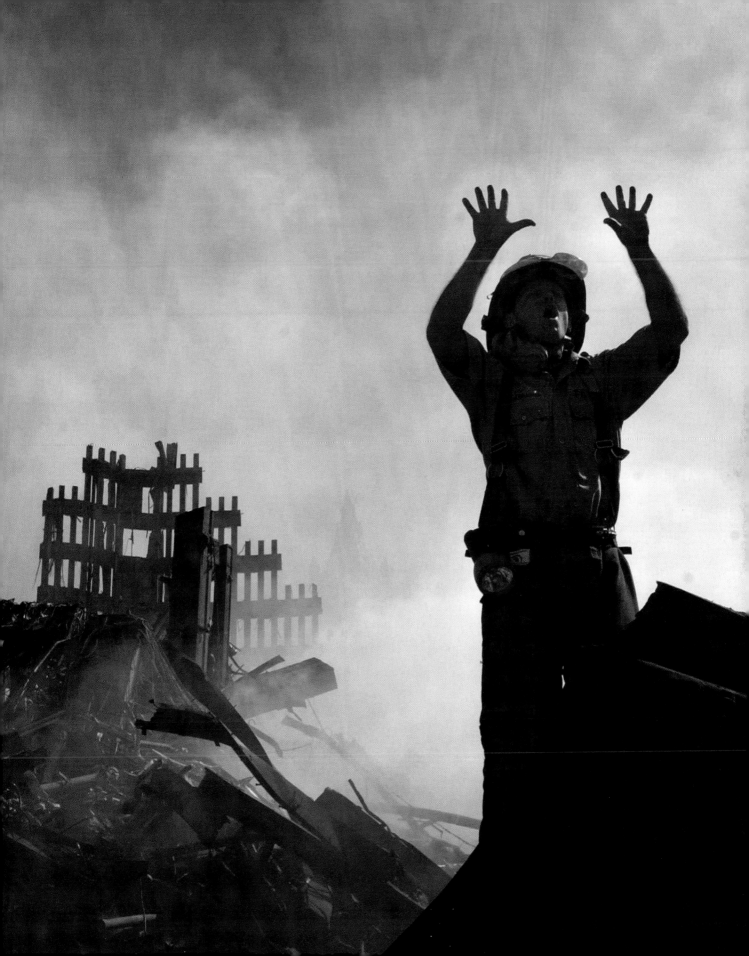

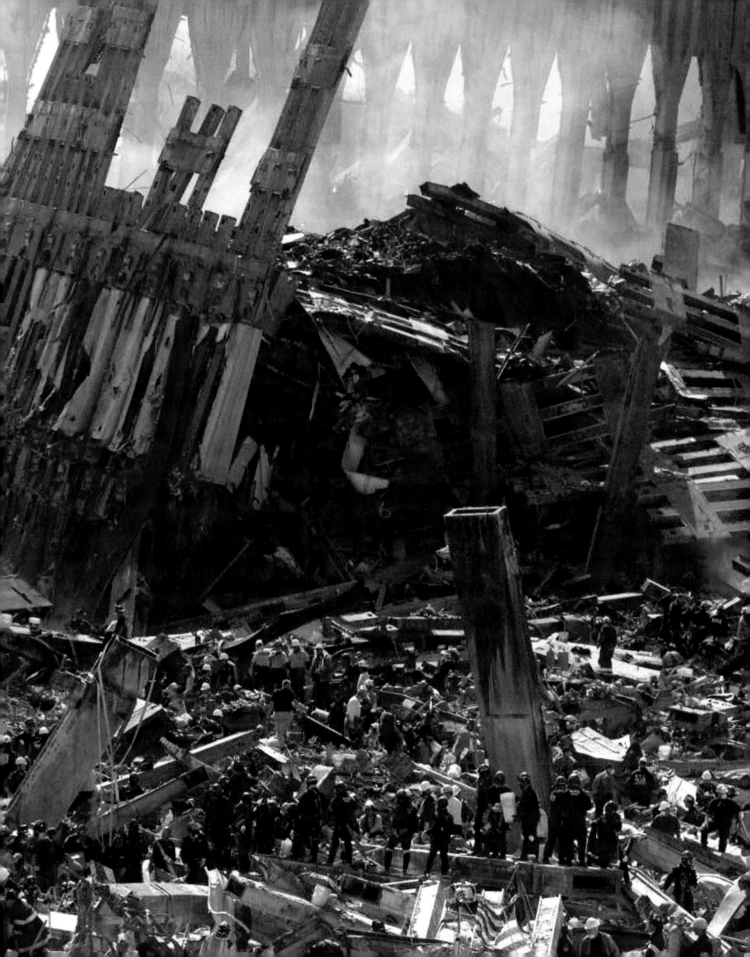

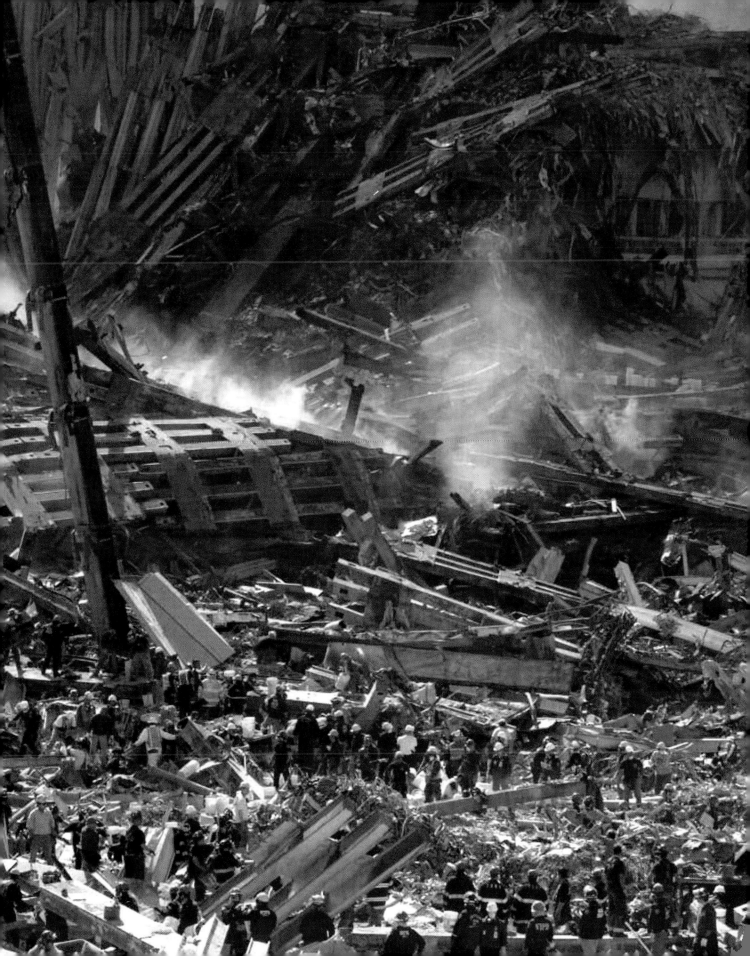

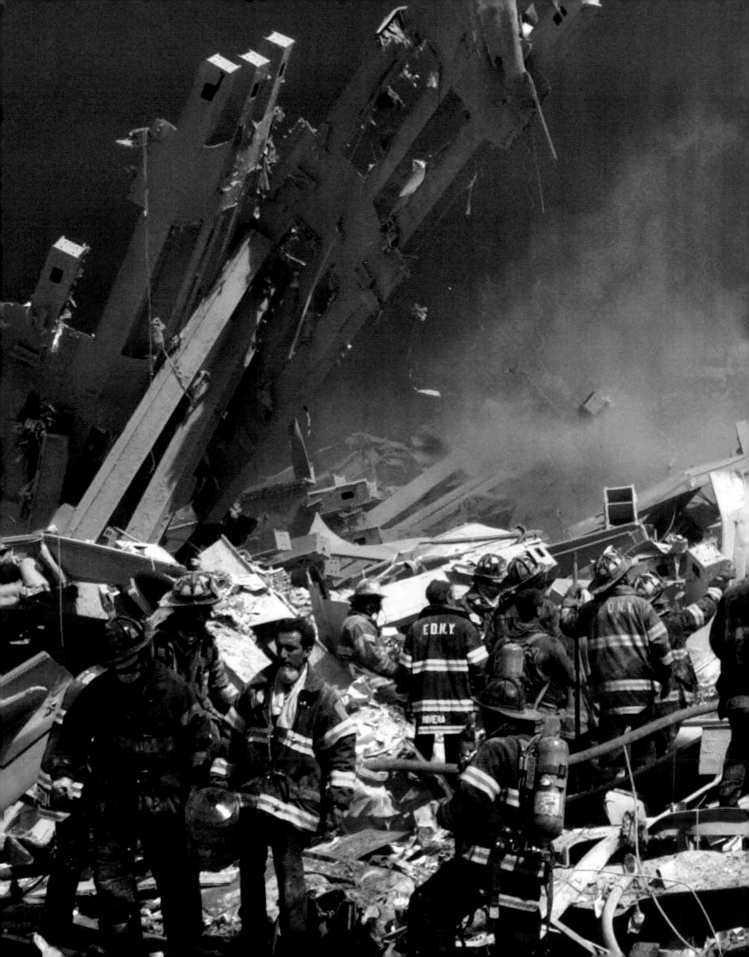

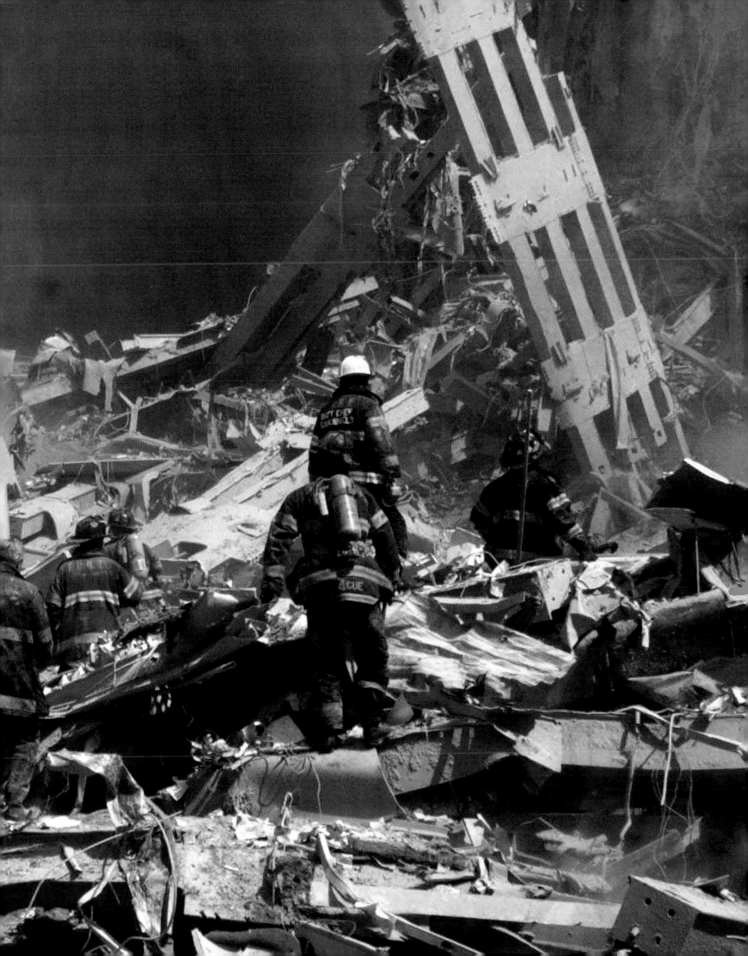

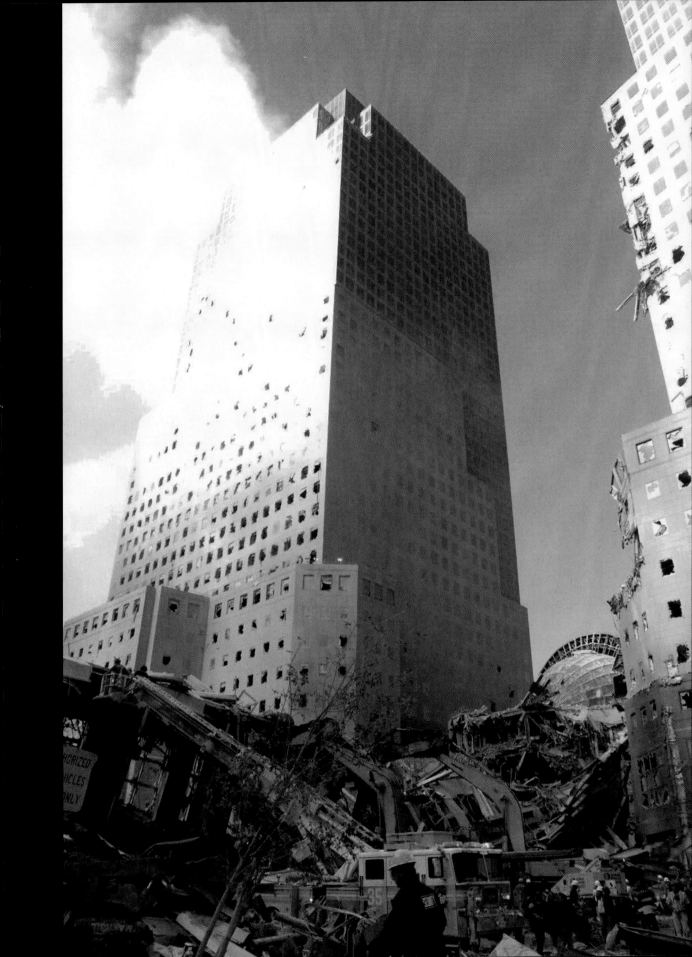

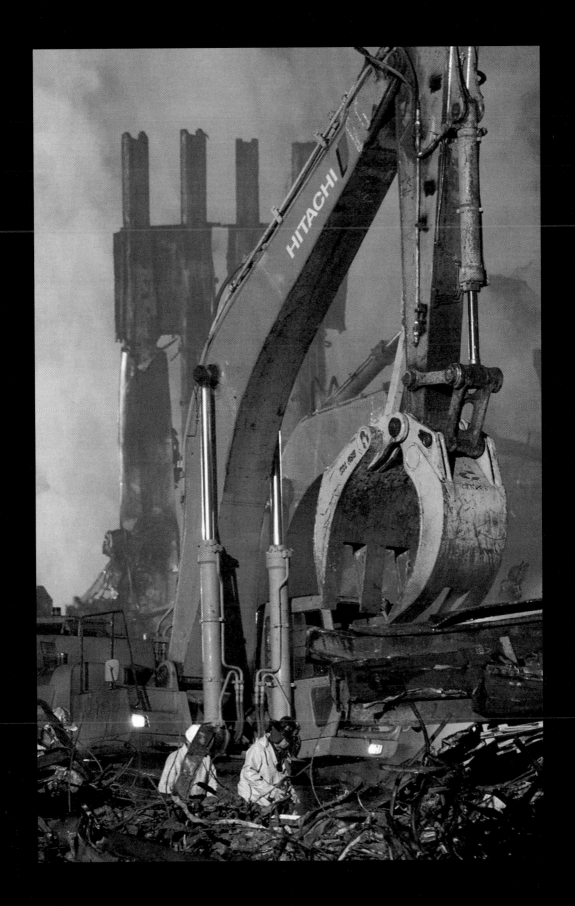

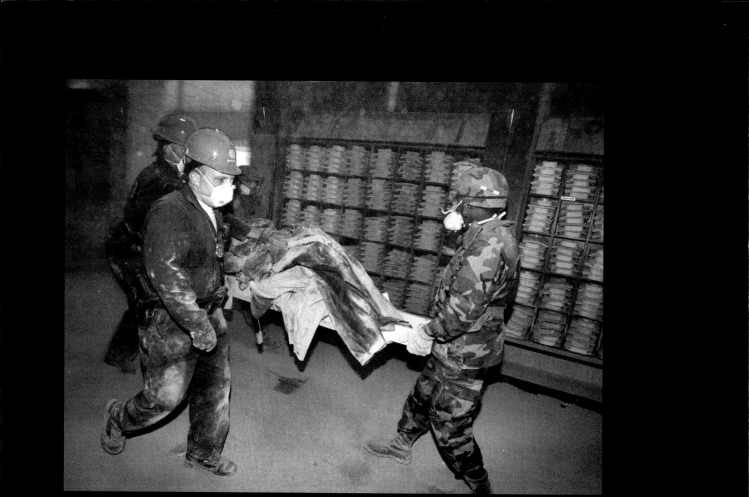

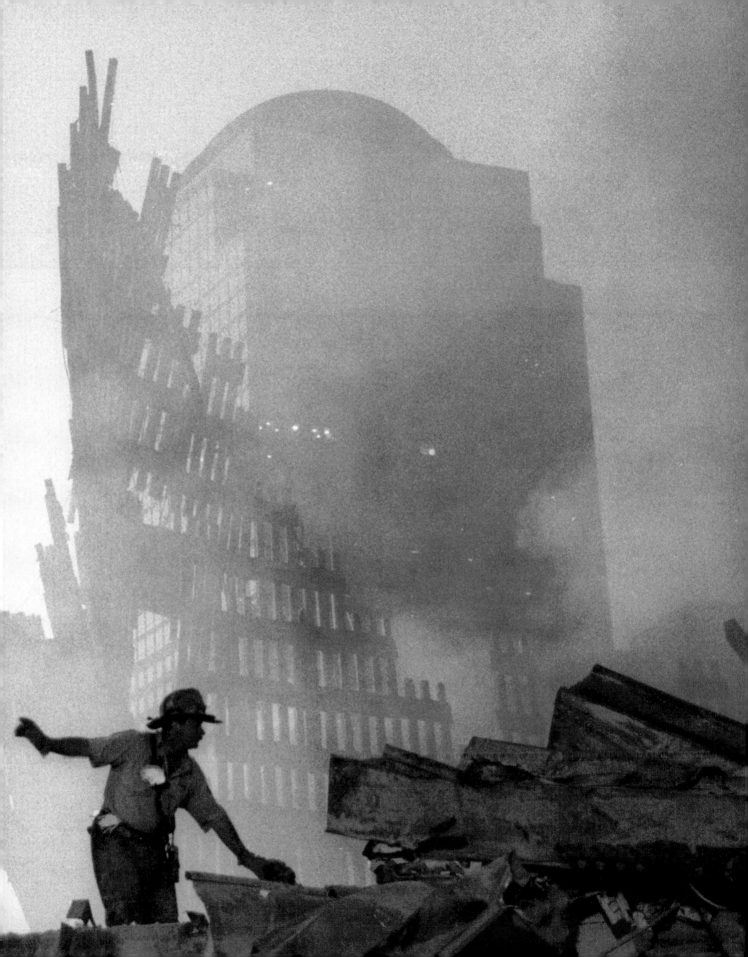

And to witness the revival of
New York in the days after the
bombing was a wondrous thing. . . .
I imagine many visitors who were
in New York on September 11
will consider themselves
New Yorkers for the rest of their
lives—myself included.

—Indigo Thomas, Slate.com,
September 24, 2001

51

Wearing bandanas and dust masks, we applauded
the streams of emergency vehicles leaving ground
zero, we shouted out thanks and the vehicles kept
coming—ambulances, troop trucks full of dusty
rescuers, semi trucks loaded with huge tangles of
metal and stairways and window glass. I reached out
and high-fived a paramedic sticking her arm from the
ambulance window. The workers stared at us in
disbelief. Expressions of confused joy began to appear
on their faces, as they honked and flashed their lights.
In the other lane, a steady rush of replacement
vehicles, sirens blaring, headed downtown.

When I finally walked away into the next street,
faint with smoke, my hands hurt from all the
clapping. If I couldn't lift wreckage and search for
survivors, at least my hands were sore from
supporting those who could.

—Craig Childs,
National Public Radio,
September 18, 2001

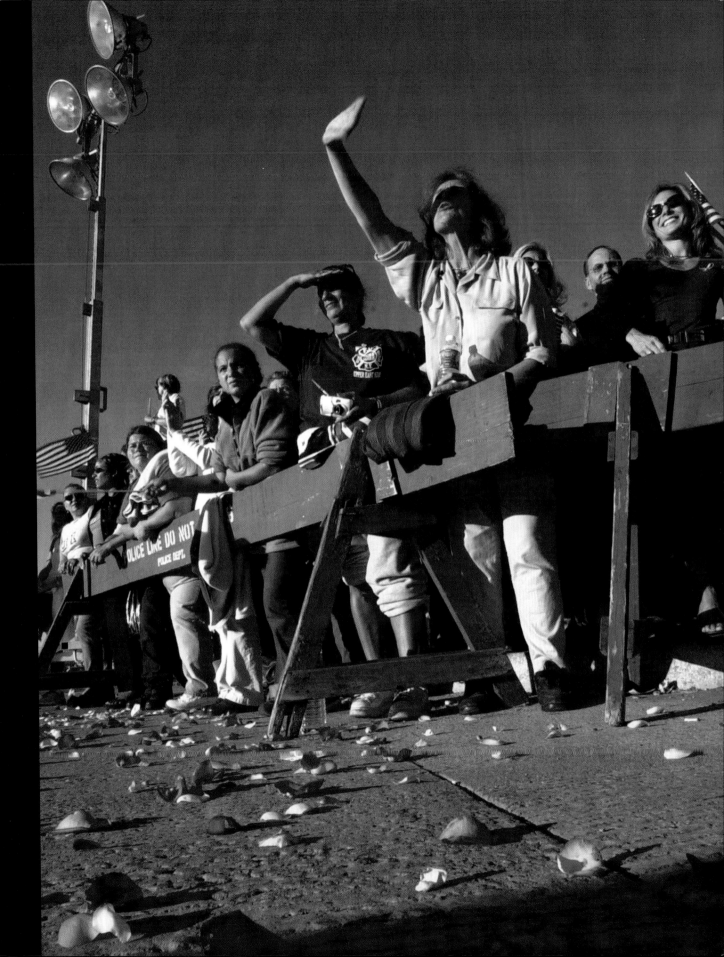

. . . pride and joy in my city,

How she led the rest to arms—how she gave the cue,

How at once with lithe limbs, unwaiting a moment, she sprang;

(O superb! O Manhattan, my own, my peerless!

O strongest you in the hour of danger, in crisis! O truer than steel!)

. .

The blood of the city up—arm'd! arm'd! the cry everywhere;

The flags flung out from the steeples of churches, and from all the public buildings and stores;

The tearful parting—the mother kisses her son—the son kisses his mother;

(Loth is the mother to part—yet not a word does she speak to detain him;)

The tumultuous escort—the ranks of policemen preceding, clearing the way;

The unpent enthusiasm—the wild cheers of the crowd for their favorites . . .

—Walt Whitman, "Drum-Taps"

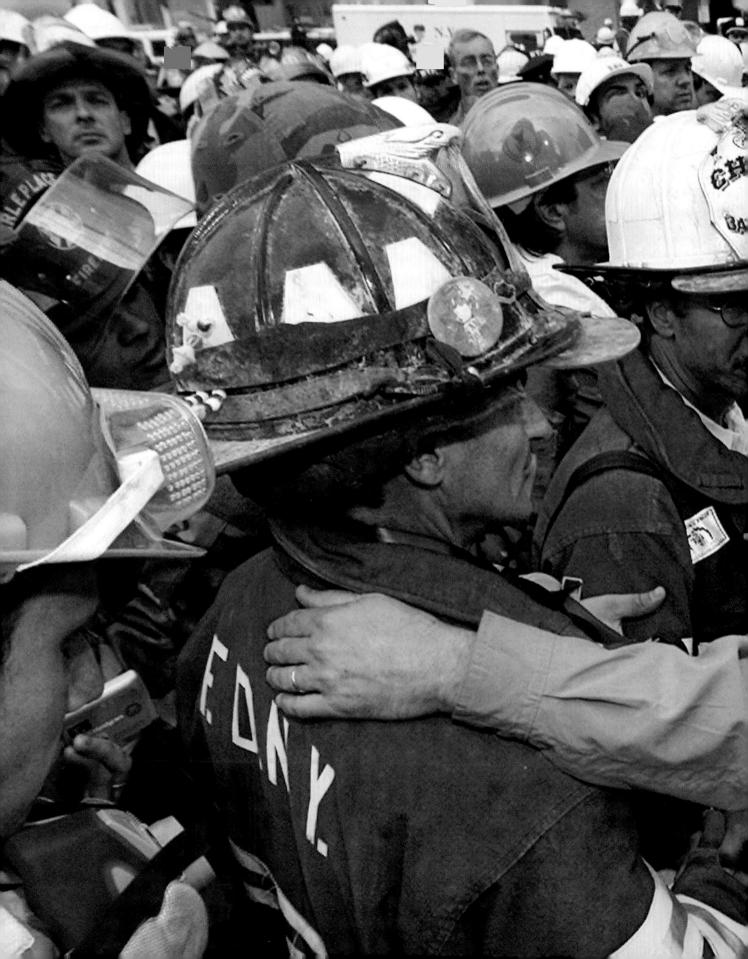

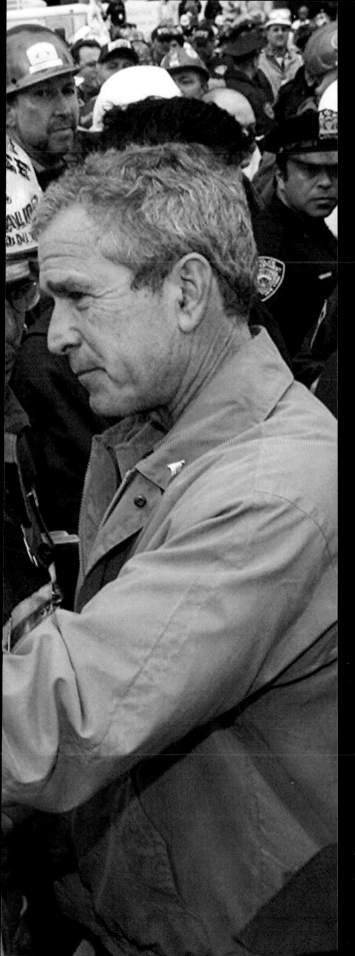

Bush choppered into lower Manhattan Friday to stand at the center of the terrorist winter, surrounded by men and women working day and night to help the living and recover the dead. He had come to thank the people the whole world wanted to thank—the cops and firefighters, the pipe fitters and welders who had left their jobs uptown to pull up the ruins downtown, the paramedics working 36-hour shifts. As much as anyone or anything, it was the images of these people doing their grim, ceaseless work that kept the country together.

—Margaret Carlson, *Time,*
September 17, 2001

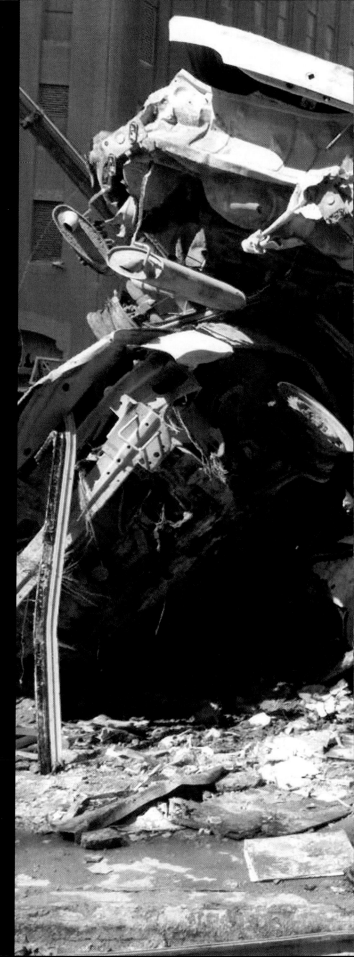

Who can look at the extraordinary sacrifices made by the firefighters and policemen of New York City and still believe that making a million dollars is the meaning of life?

—Fareed Zakaria, *Newsweek,*
September 24, 2001

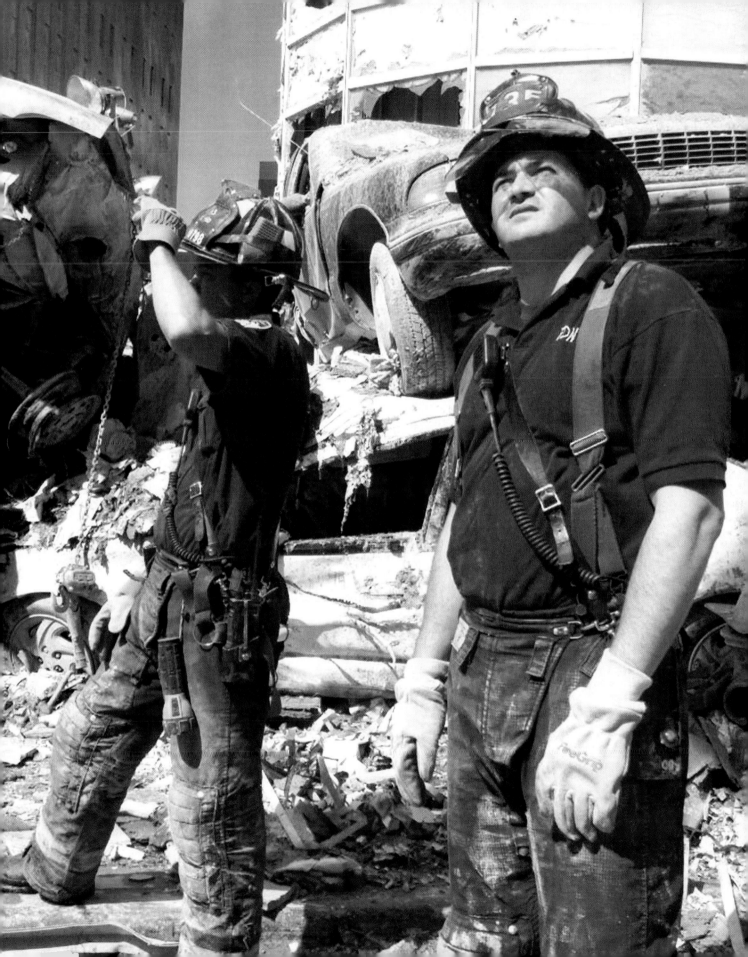

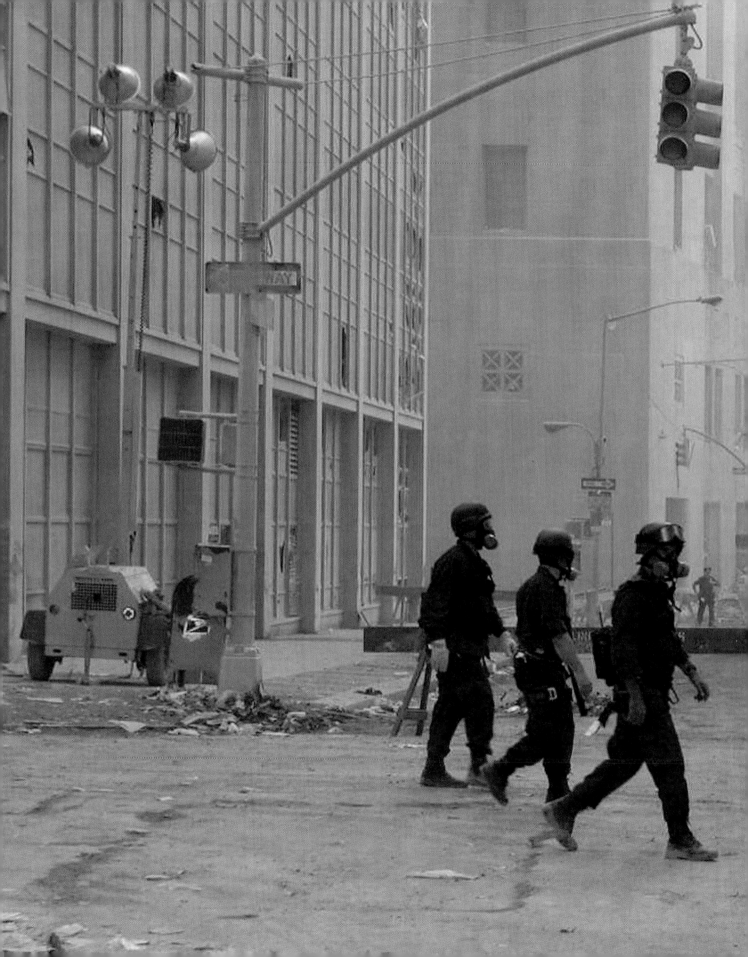

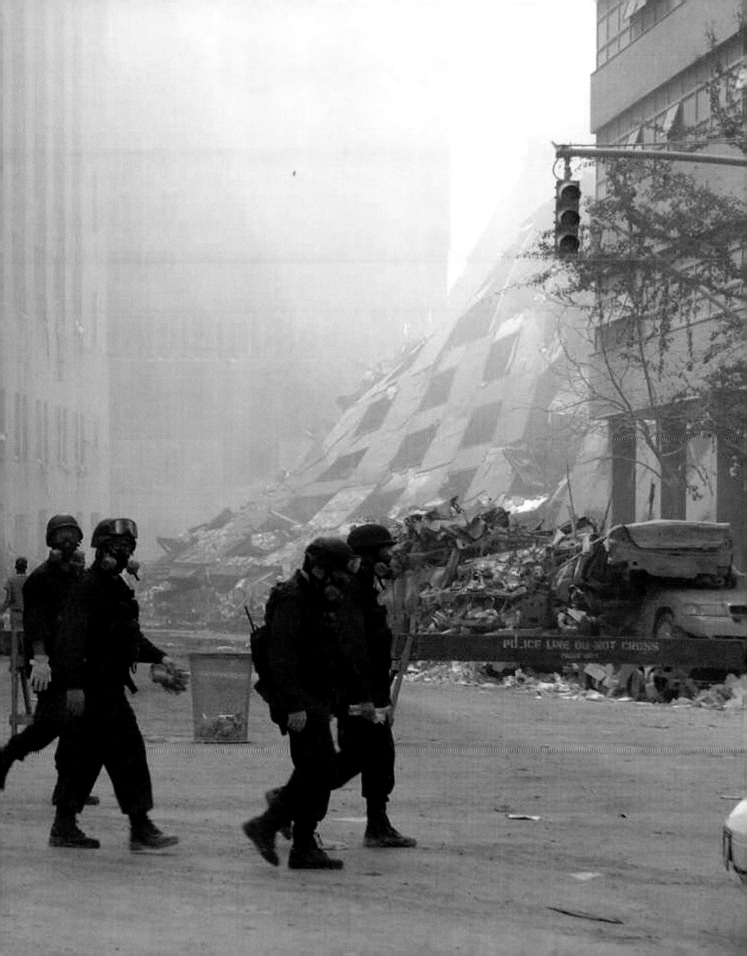

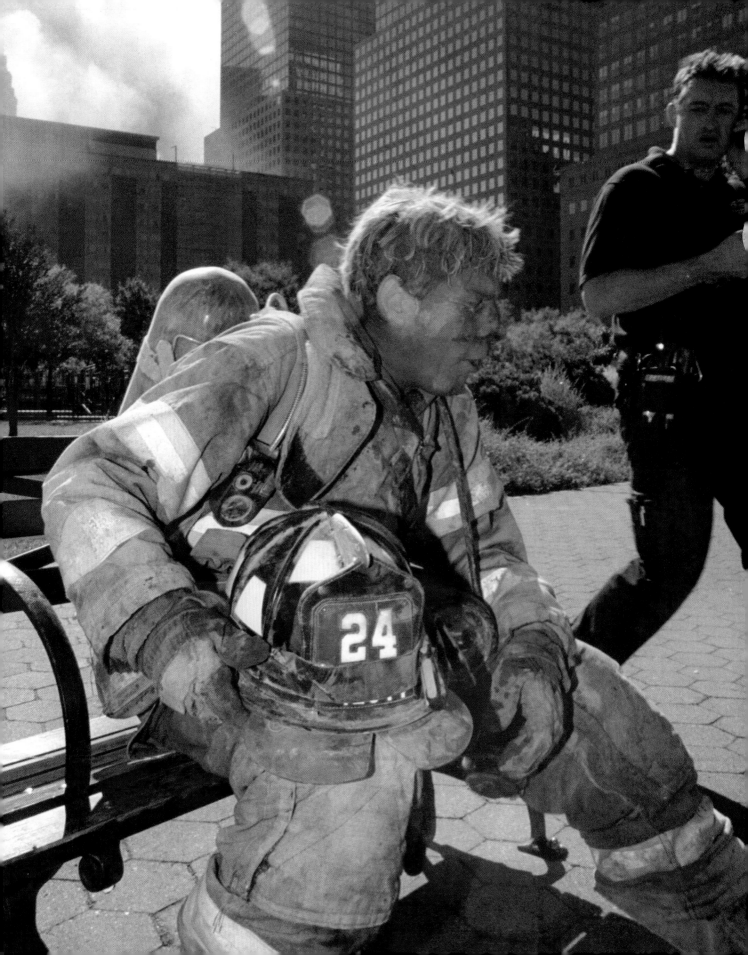

It is said that adversity introduces us to
ourselves. This is true of a nation as well.
In this trial, we have been reminded
and the world has seen that our fellow
Americans are generous and kind,
resourceful and brave. We see our
national character in rescuers working
past exhaustion, in long lines of blood
donors, in thousands of citizens who
have asked to work and serve in any way
possible. And we have seen our national
character in eloquent acts of sacrifice.

—President George W. Bush,
September 11, 2001

63

They helped every one his neighbor;
and every one said to his brother,
Be of good courage.

—Isaiah 41:6

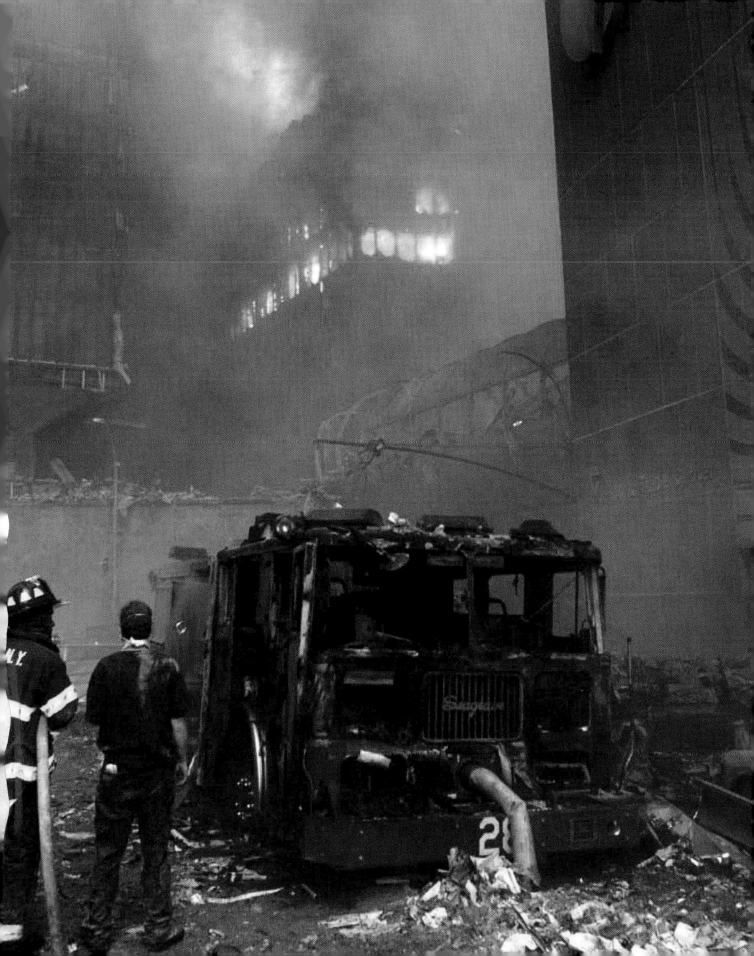

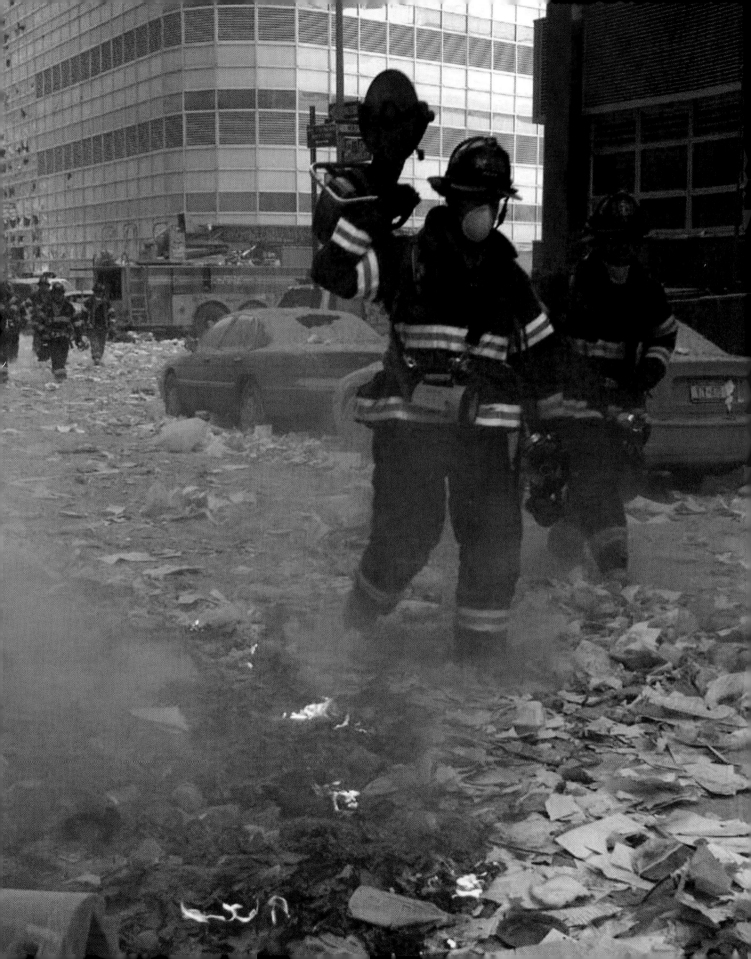

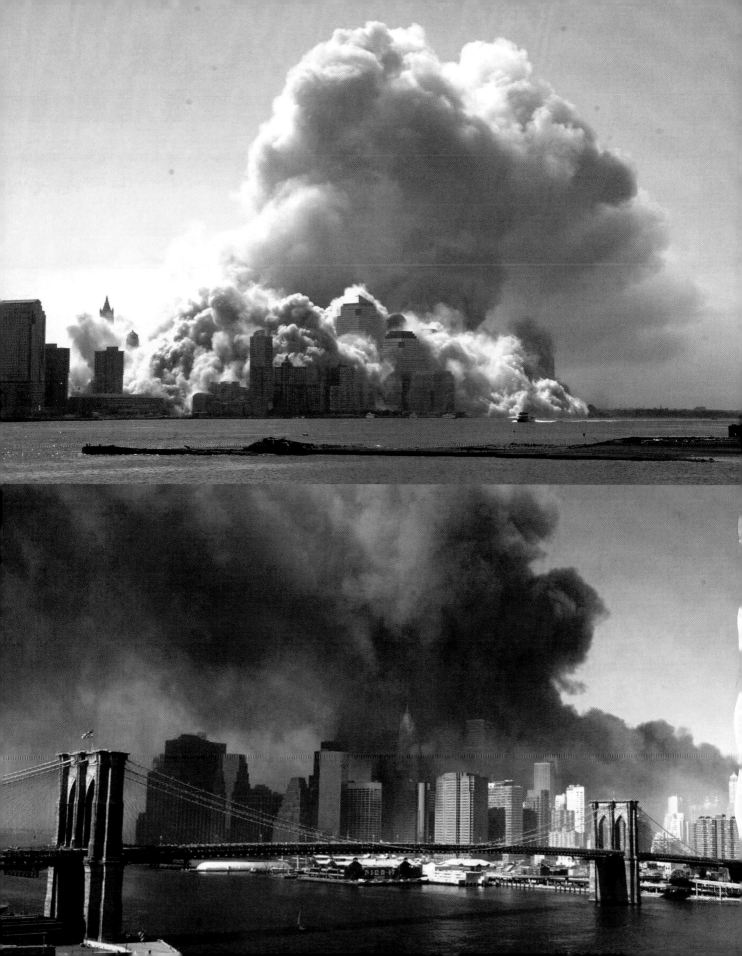

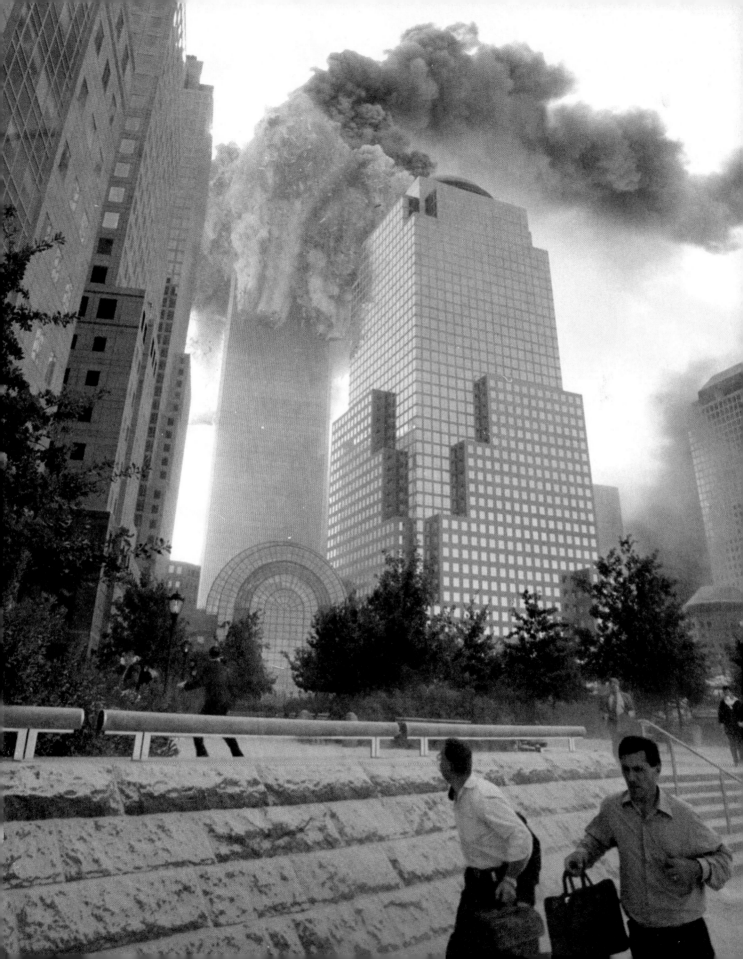

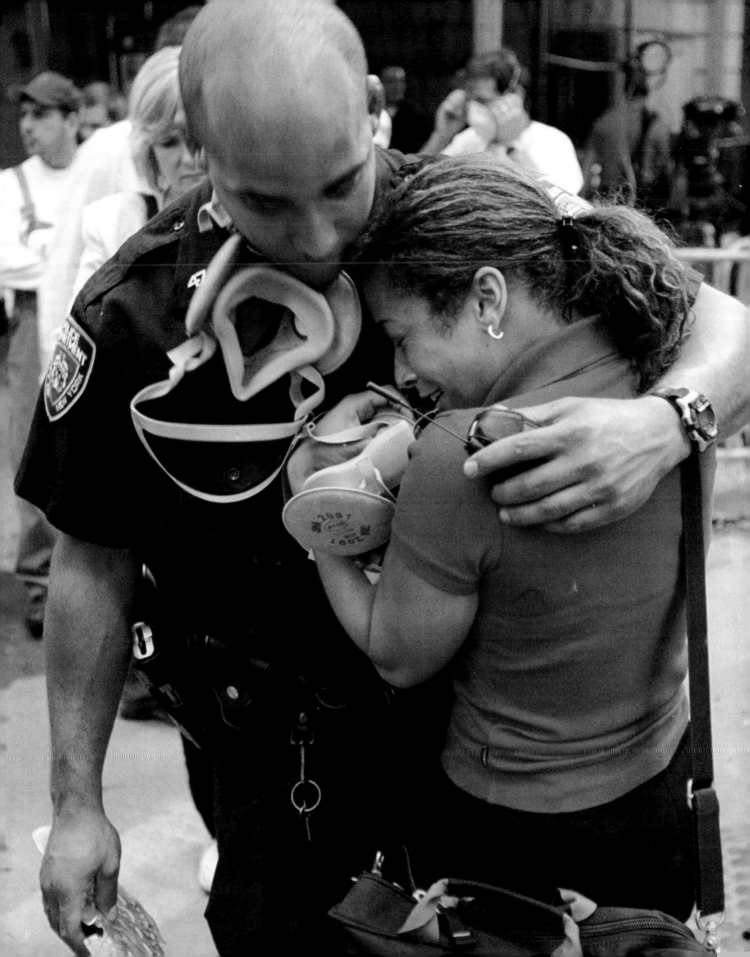

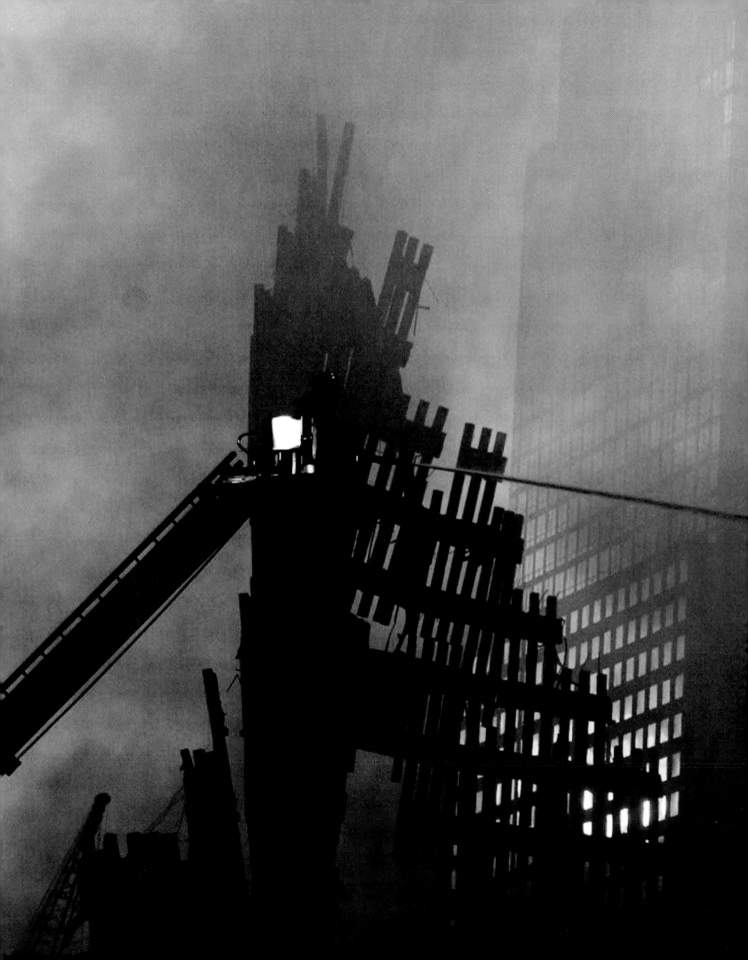

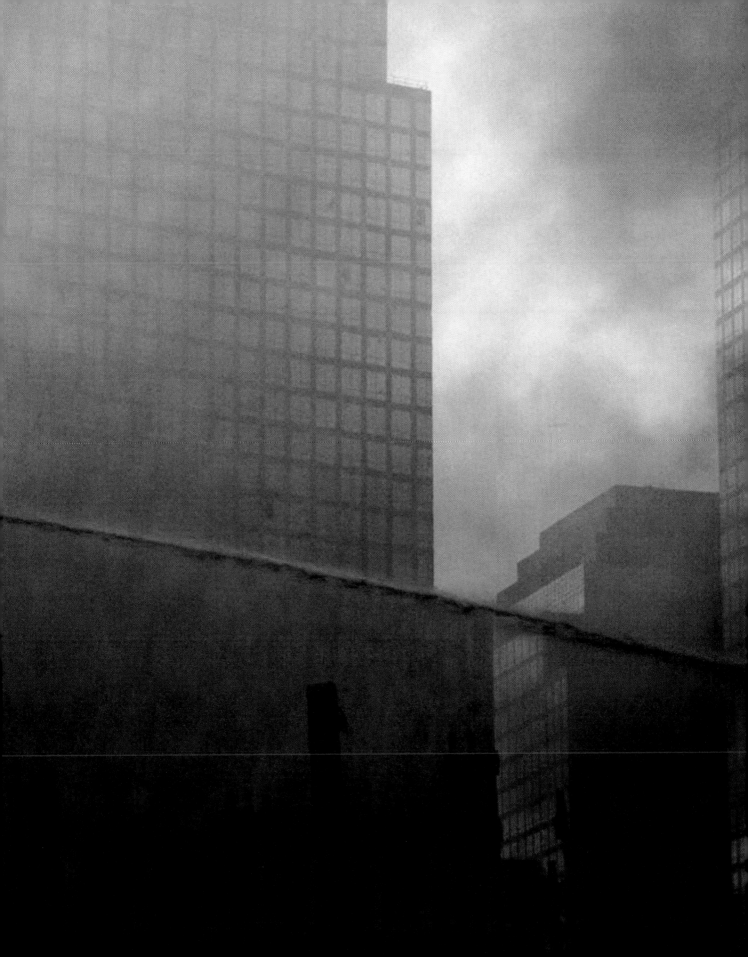

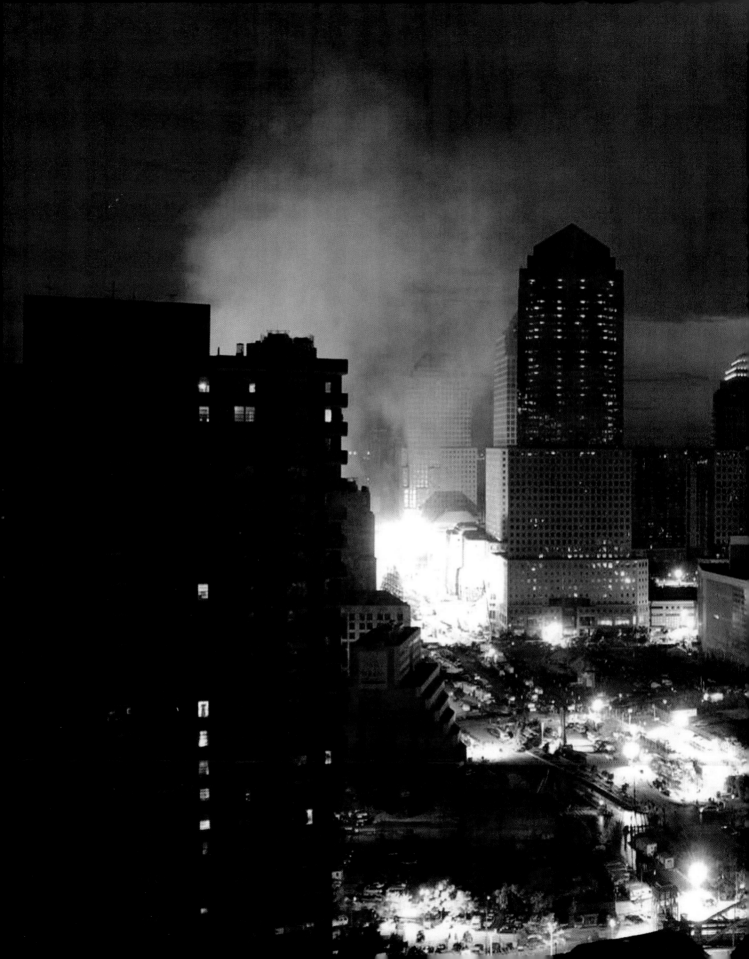

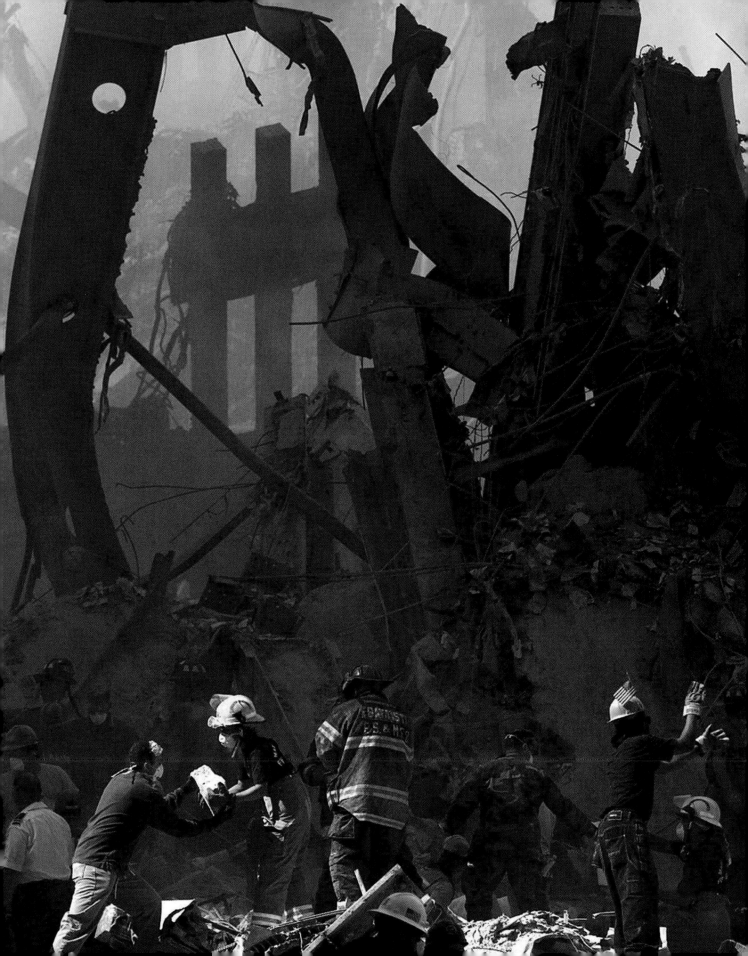

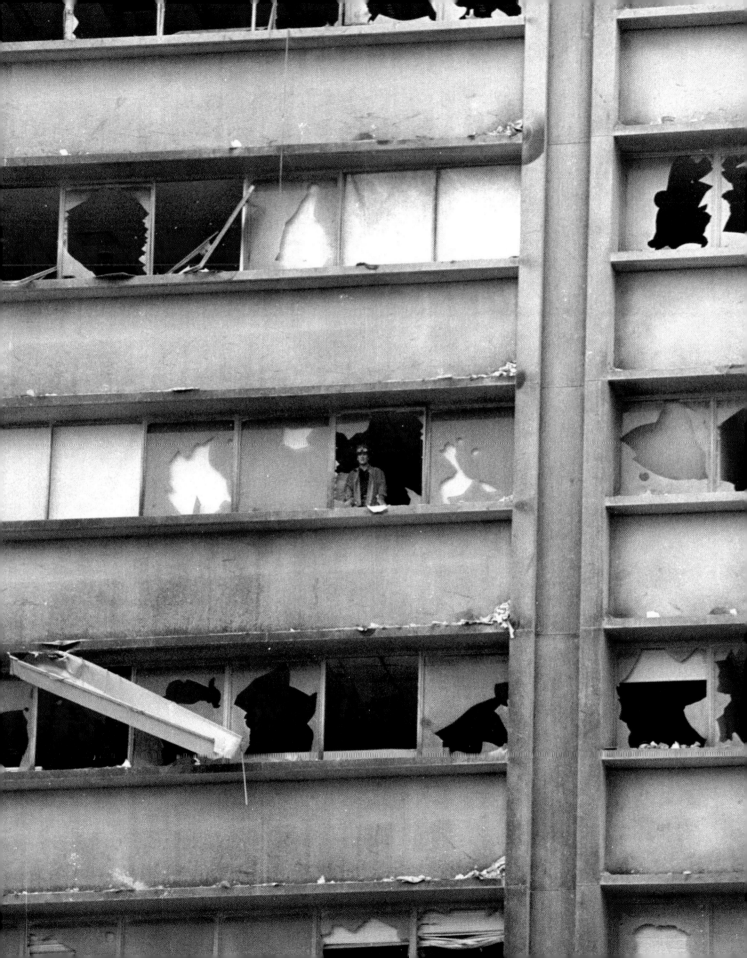

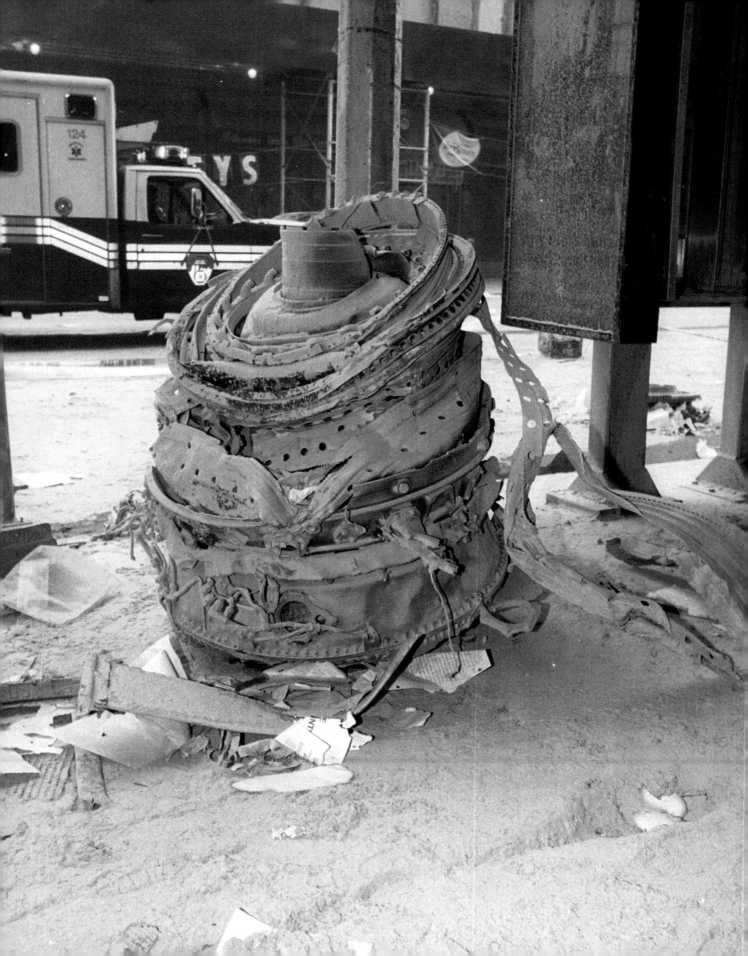

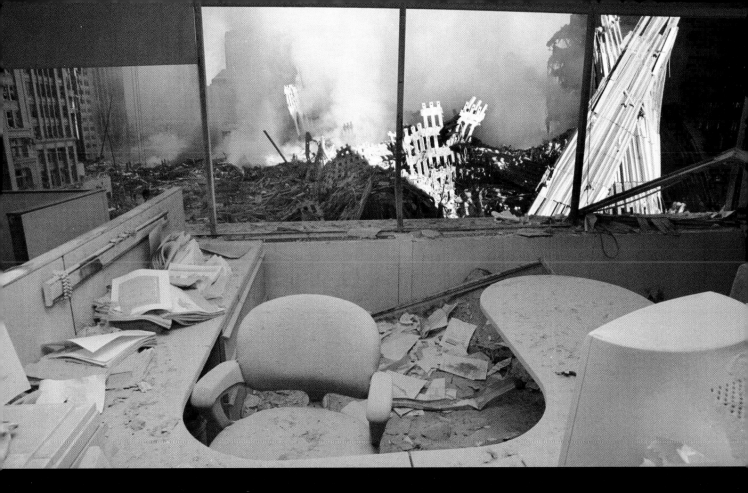

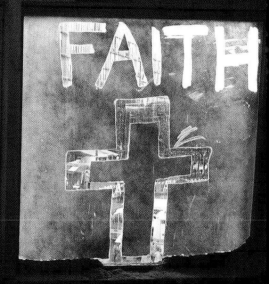

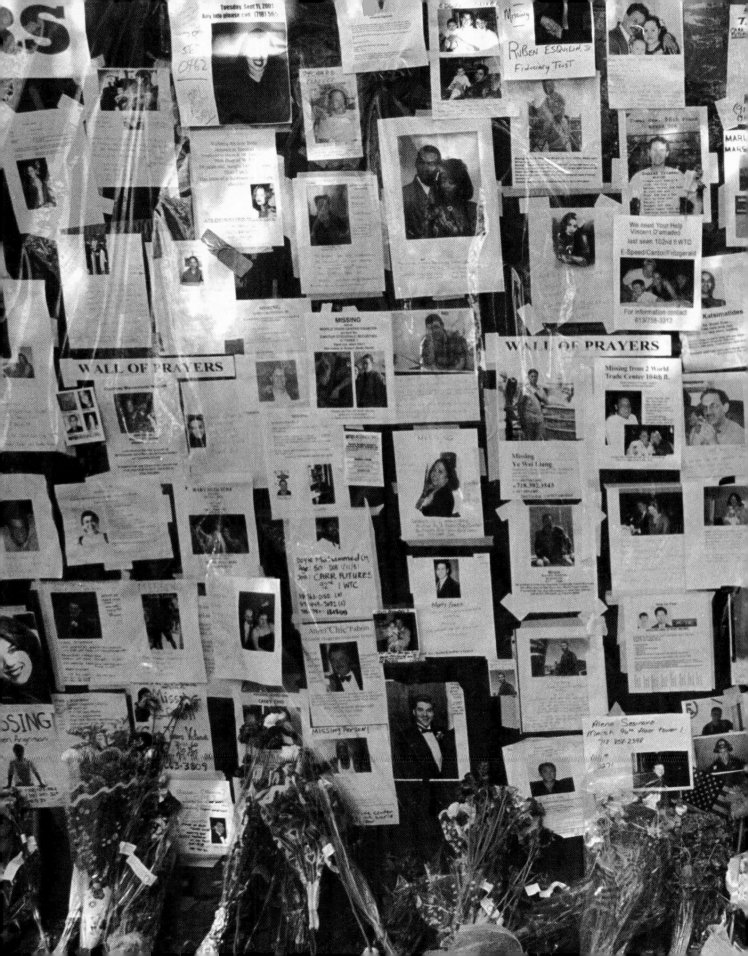

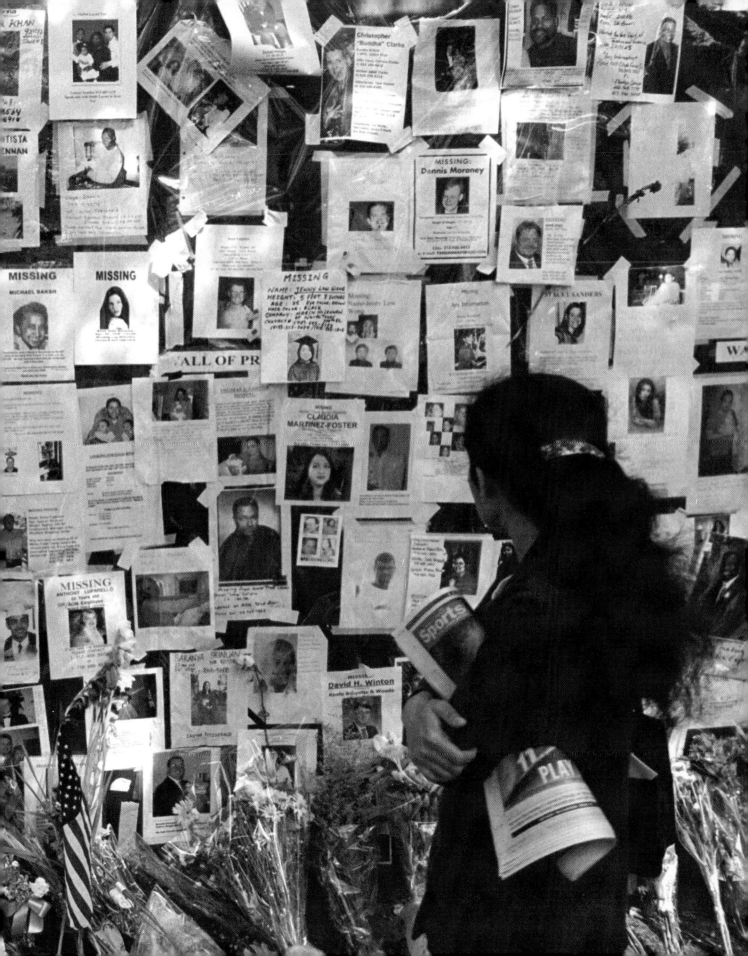

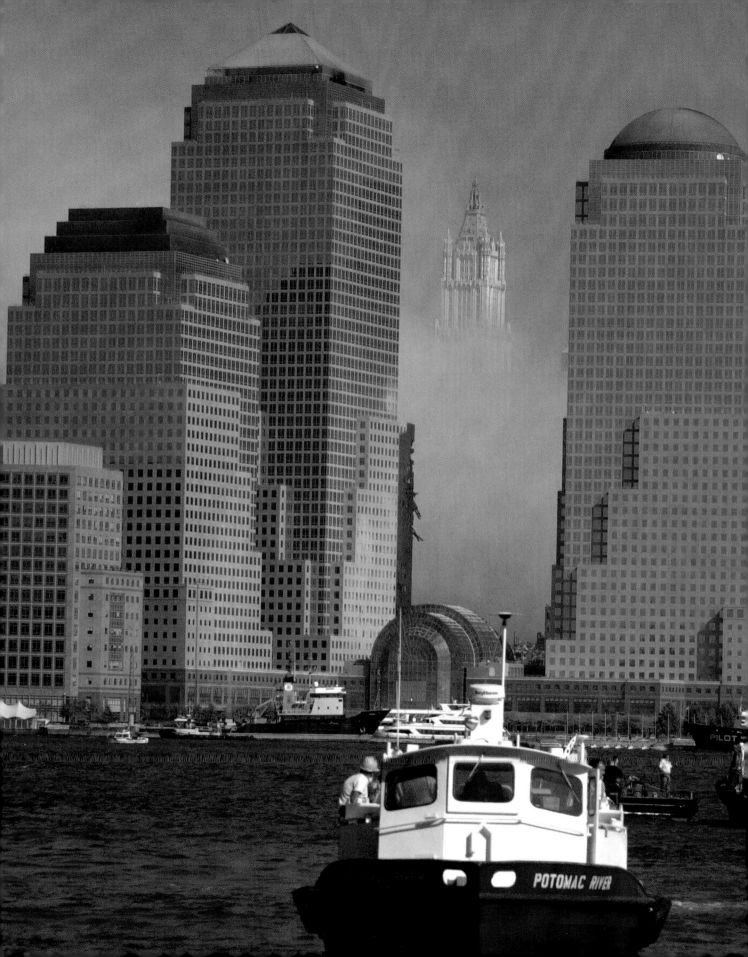

To *triumph over the calamities
and terrors of mortal life is the
part of a great man only. . . .
Disaster is Virtue's opportunity.*

—Seneca

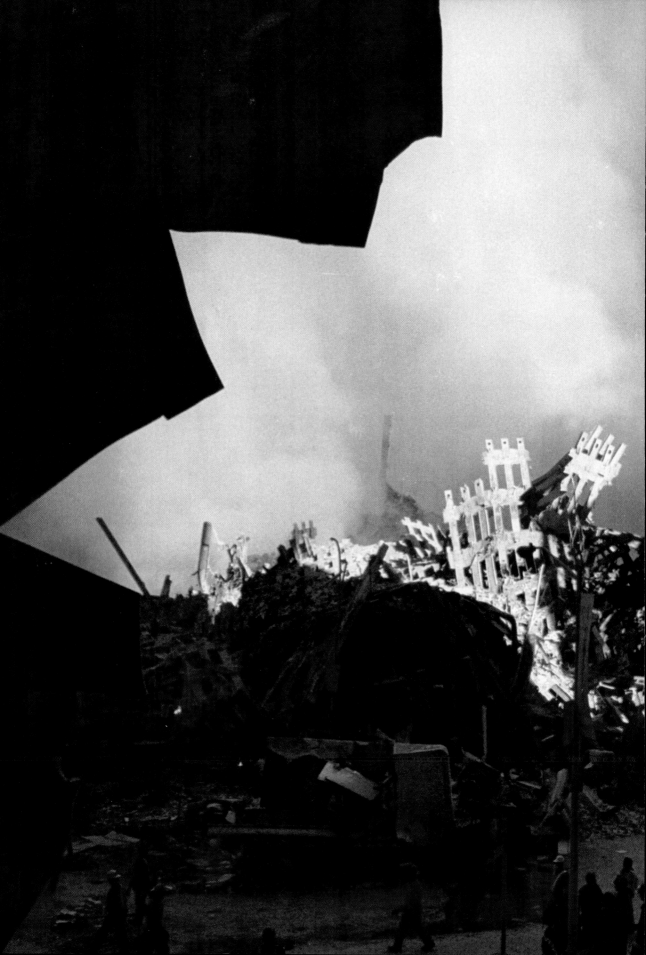

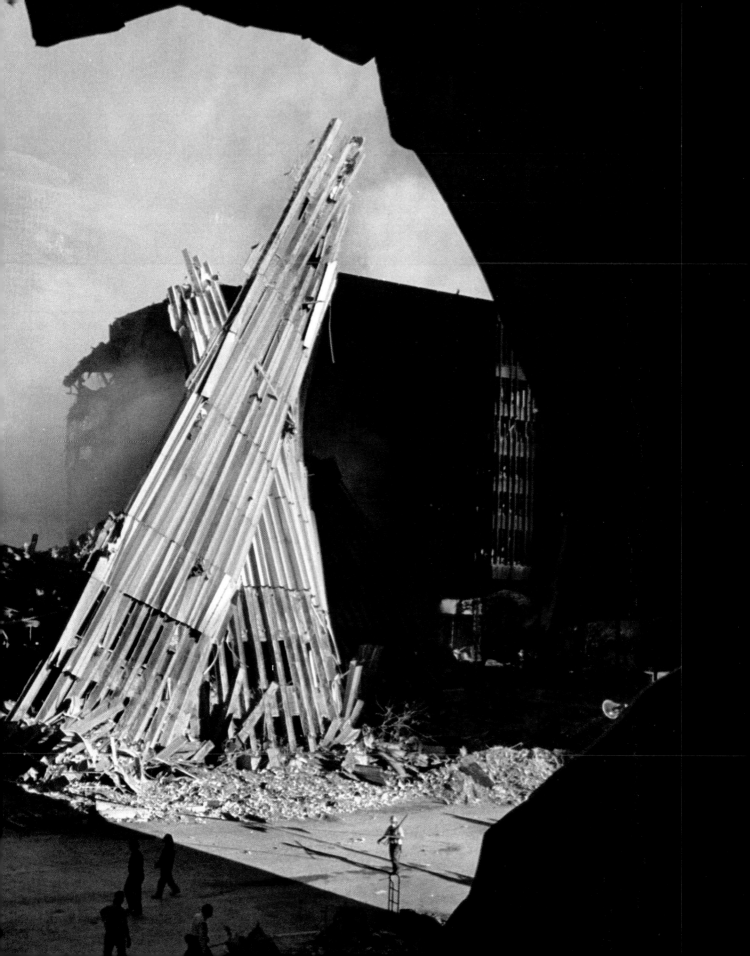

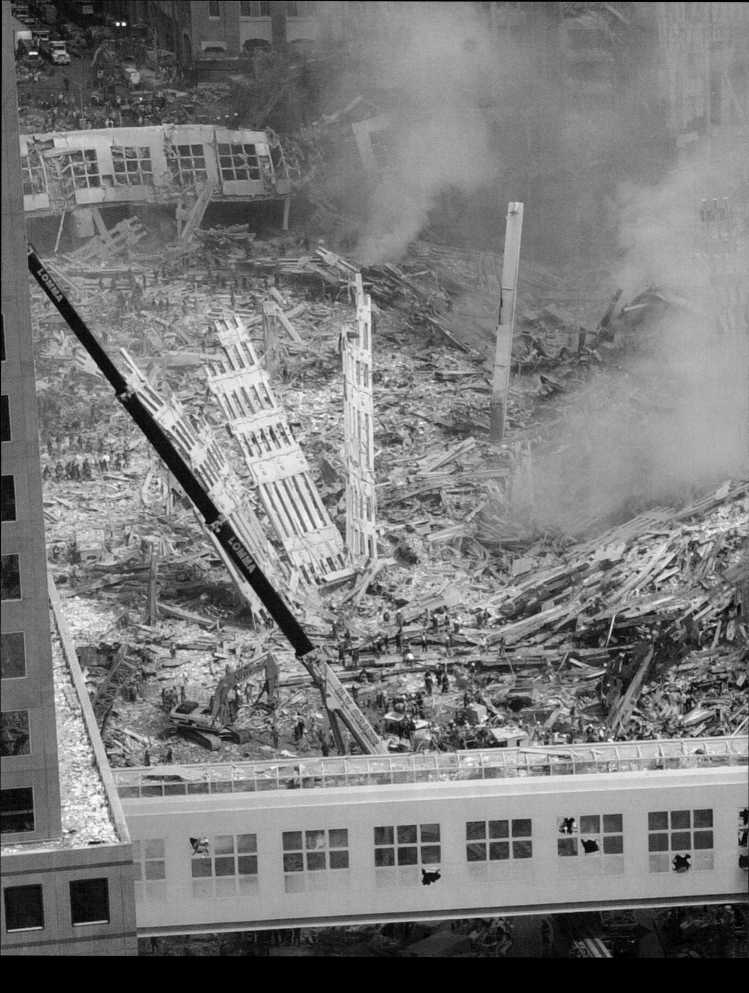

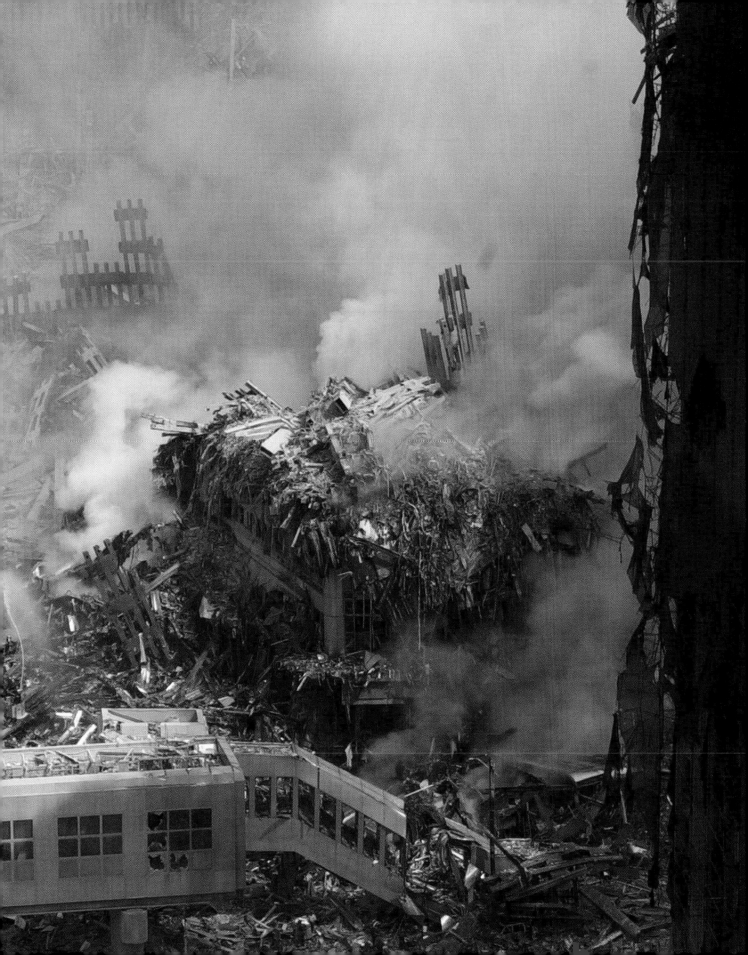

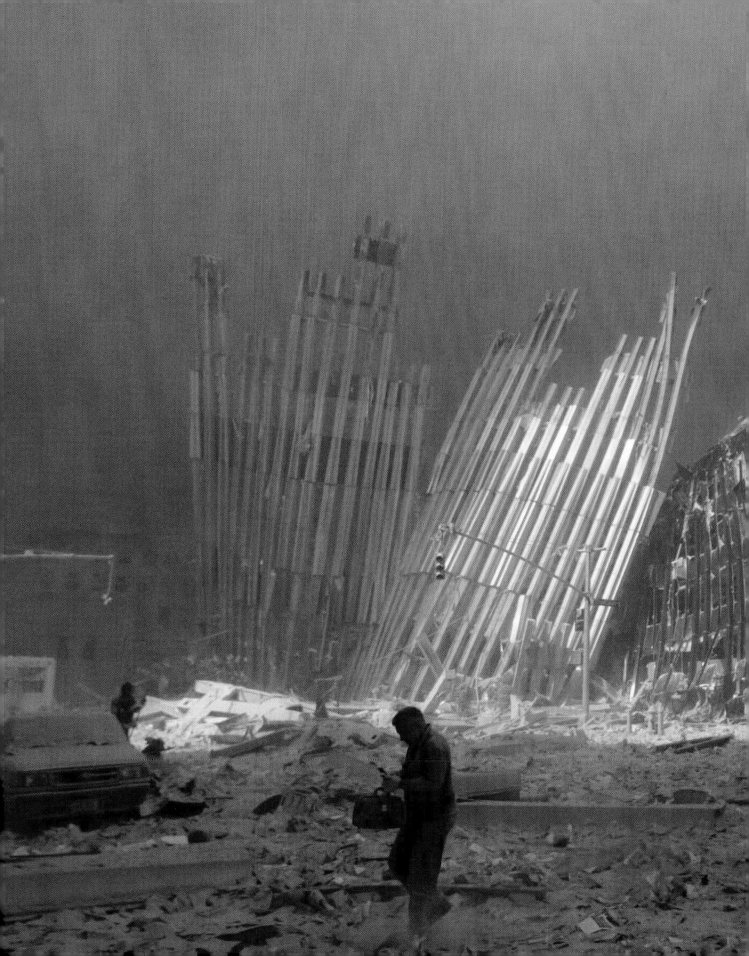

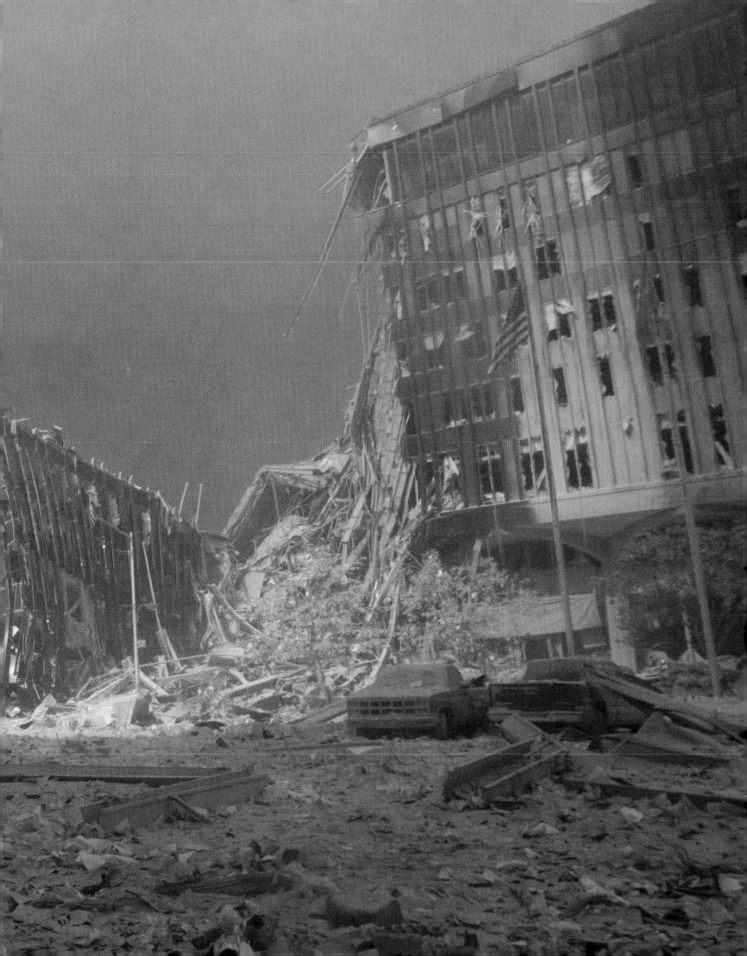

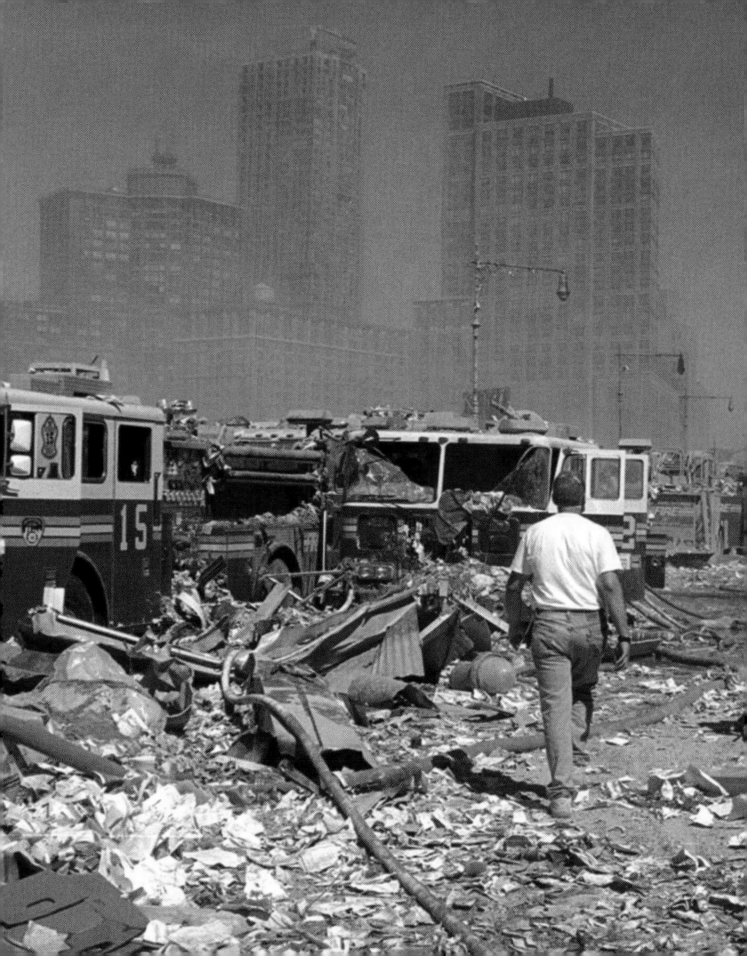

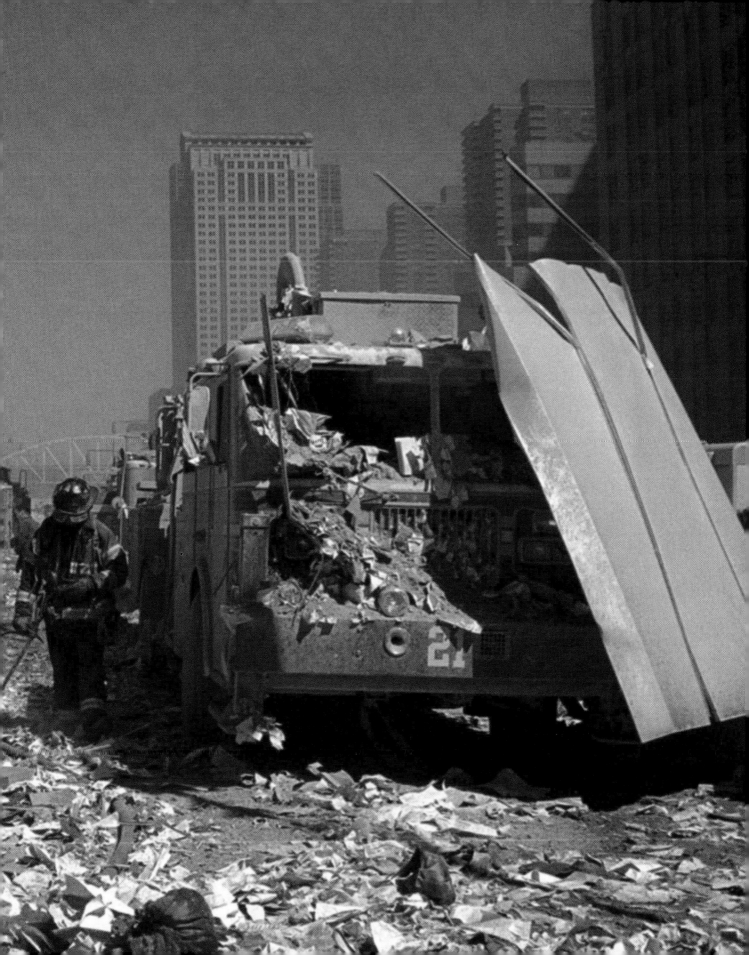

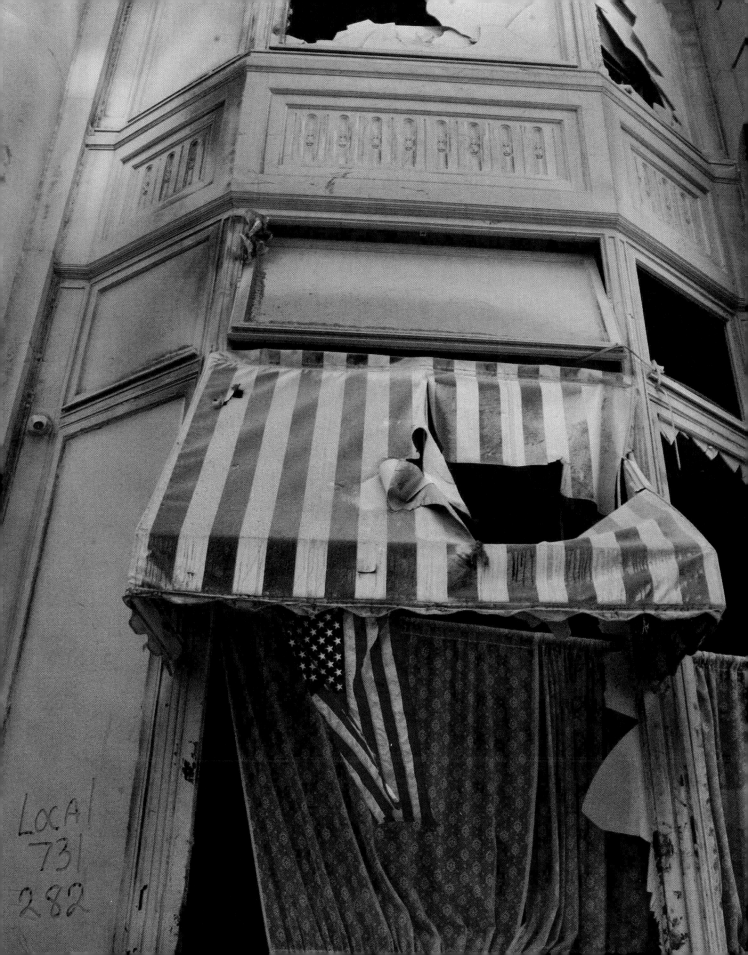

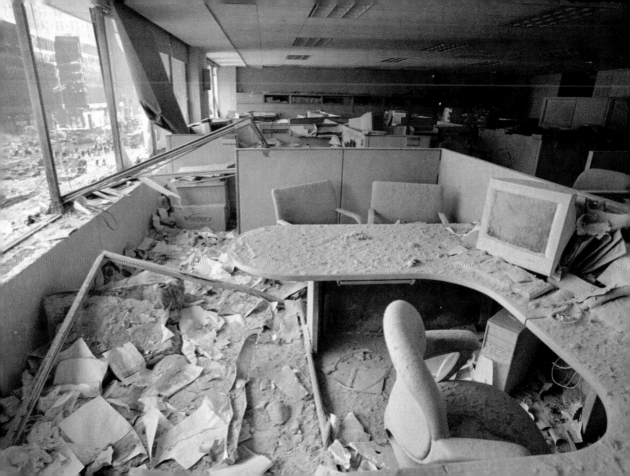

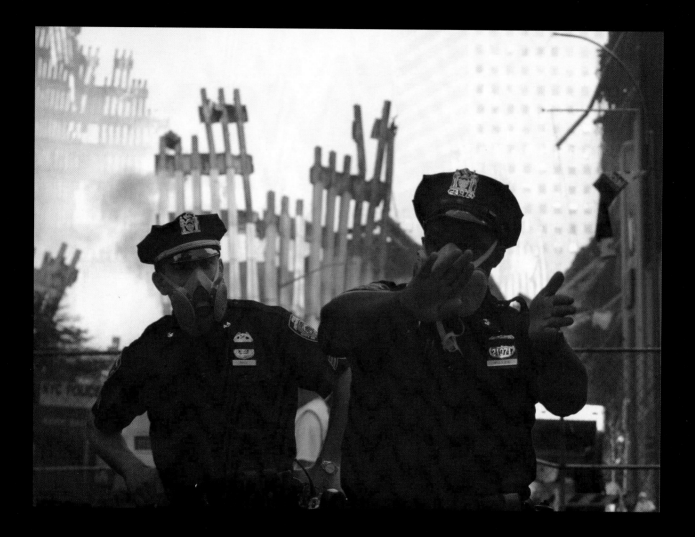

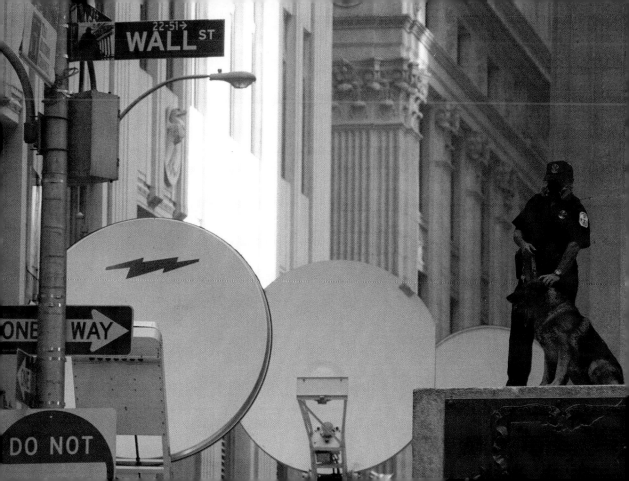

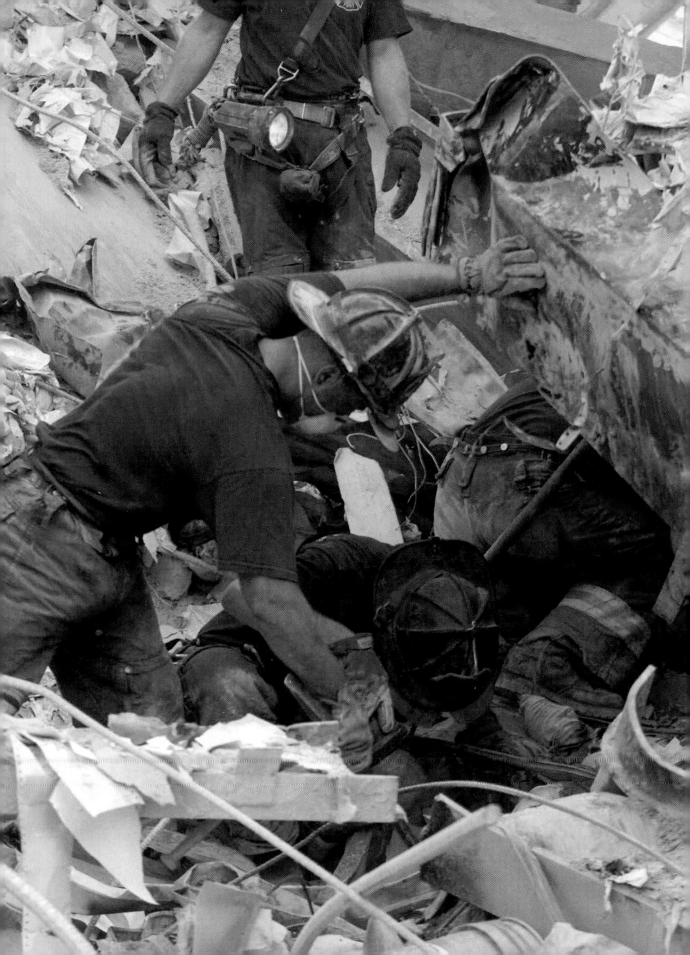

God was there in the seat with every person who went down in the fiery inferno. . . . He was in the fireman's suit and behind the police badge. God was there in the elevators and the stairwells of the World Trade Center.

—Reverend Sam Stover,
Mason United Methodist Church,
Mason, Ohio

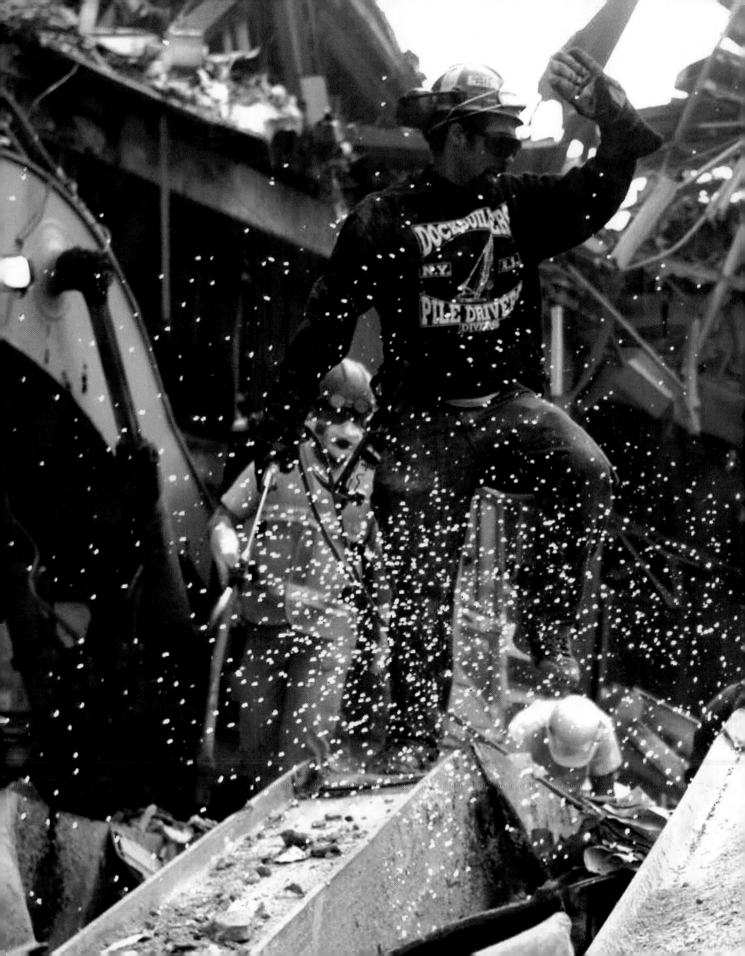

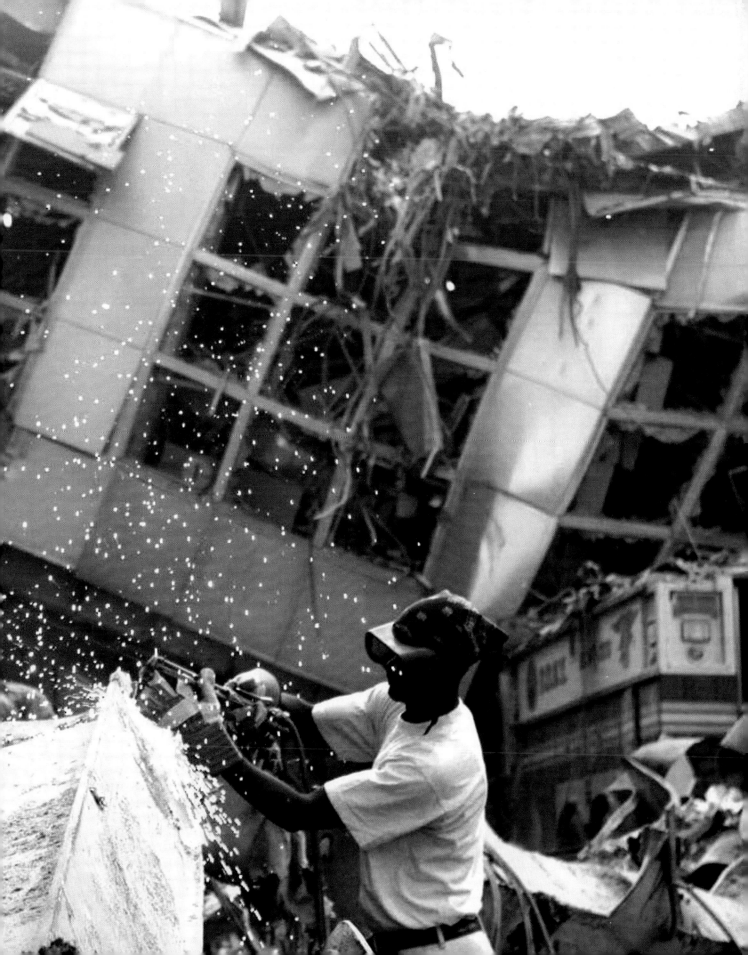

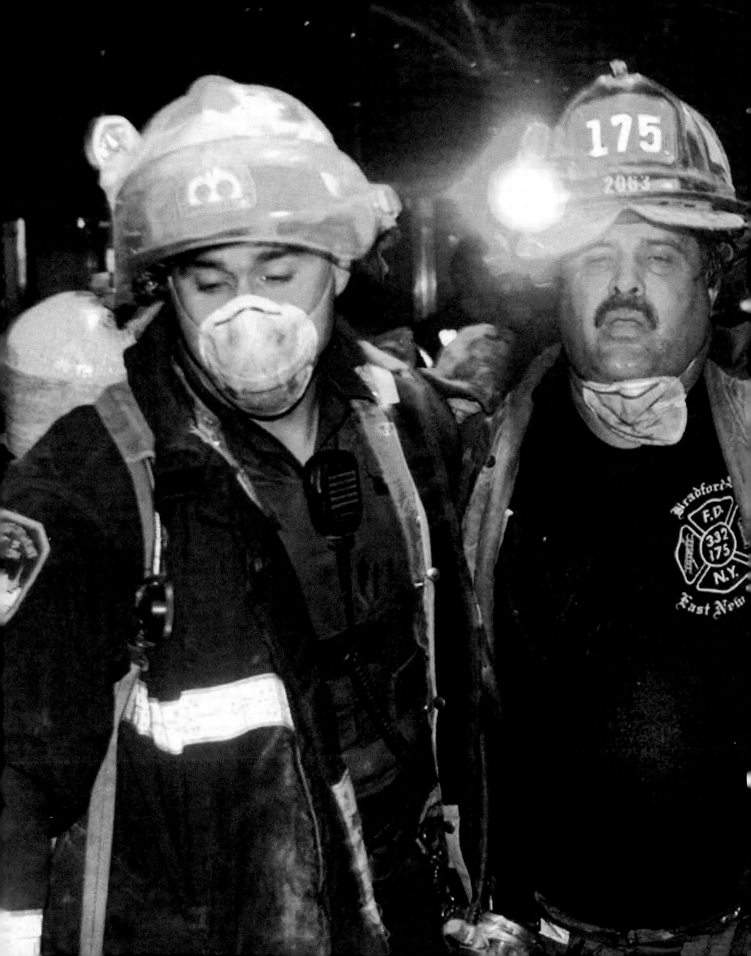

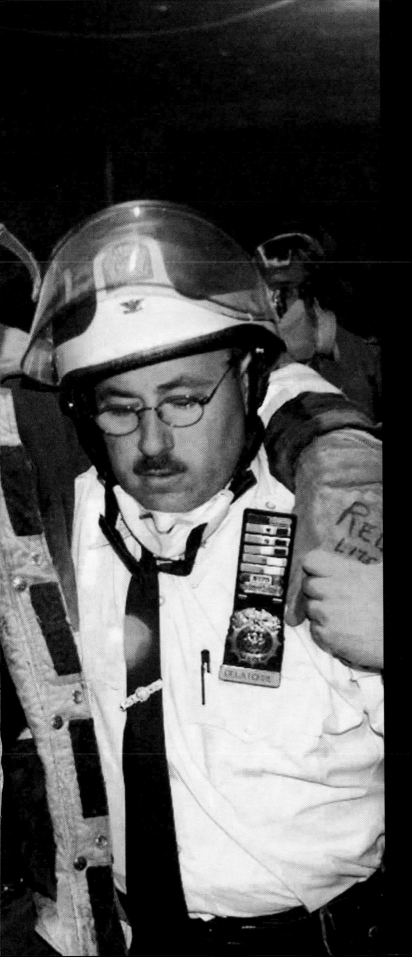

Pause for a moment and consider the weight of those words—"honor" and "hero." These are not words to be used lightly. They are words we reserve for those who make a conscious decision to give their all. Certainly these words are appropriate for the men and women of New York City who wore the uniform.

—Governor Frank O'Bannon, Indiana

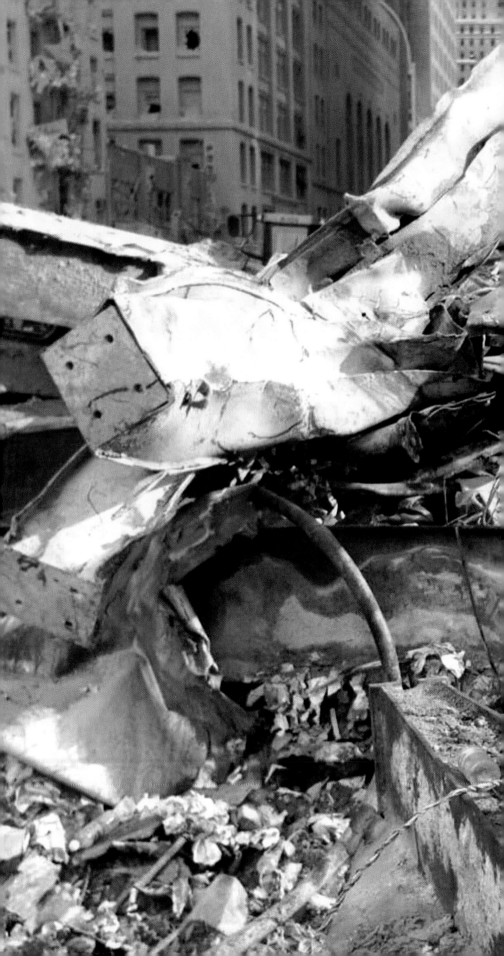

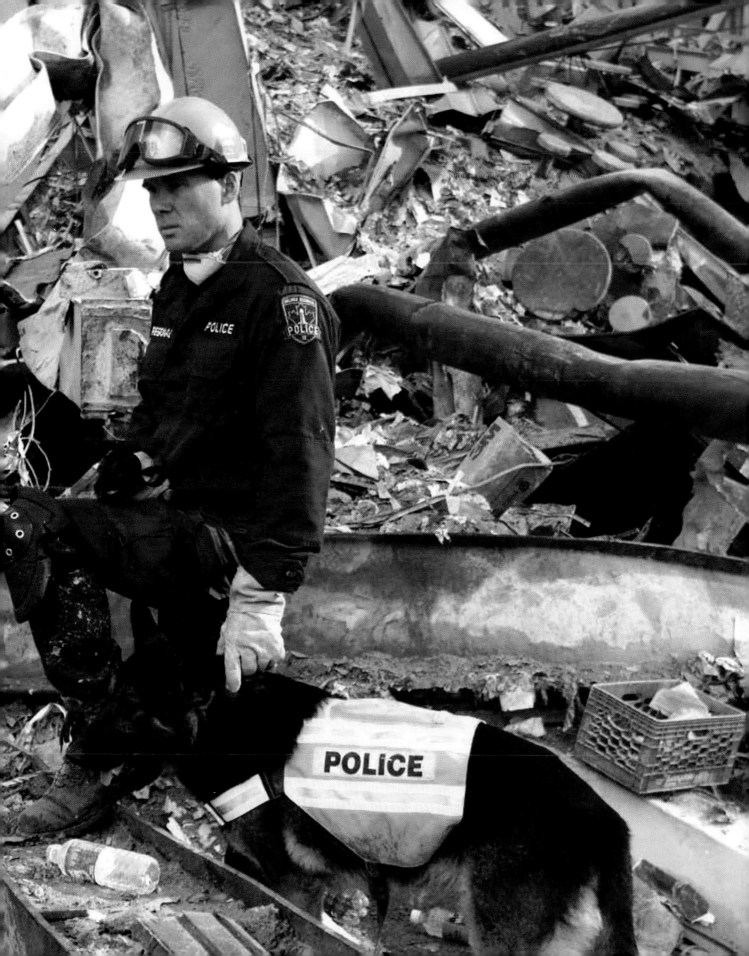

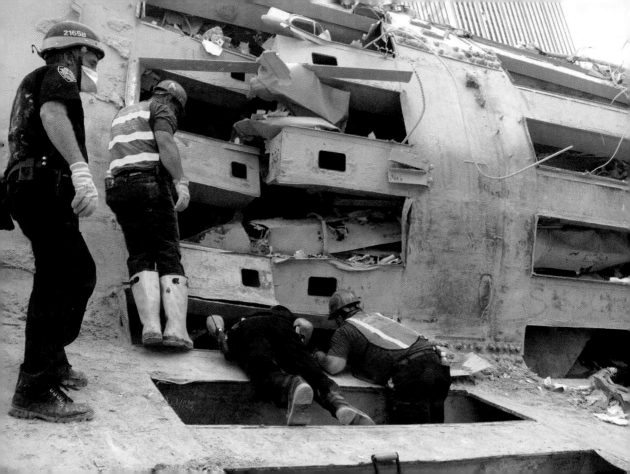

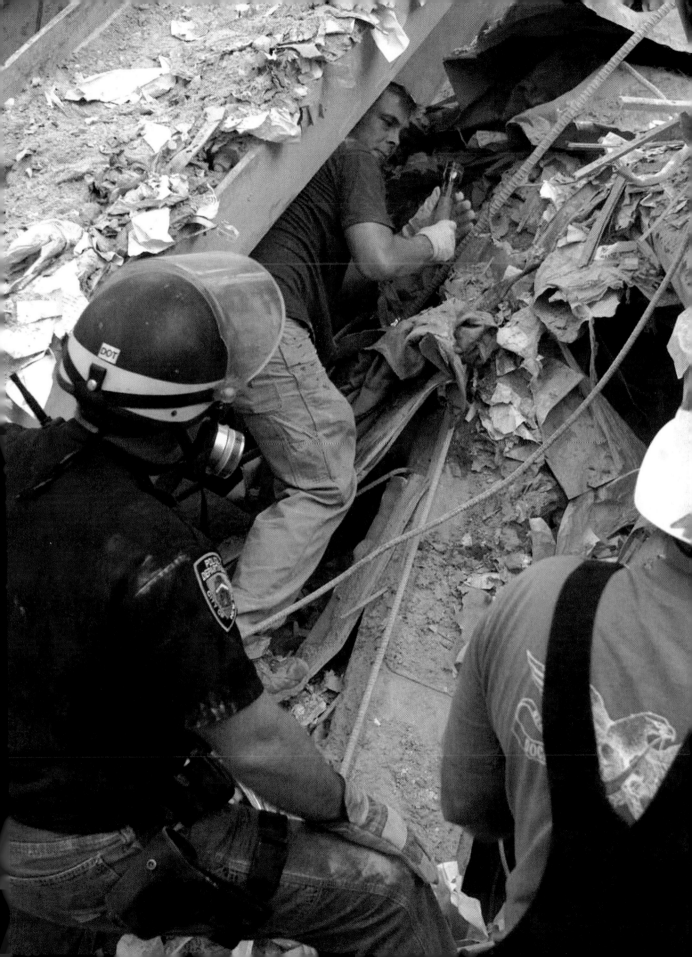

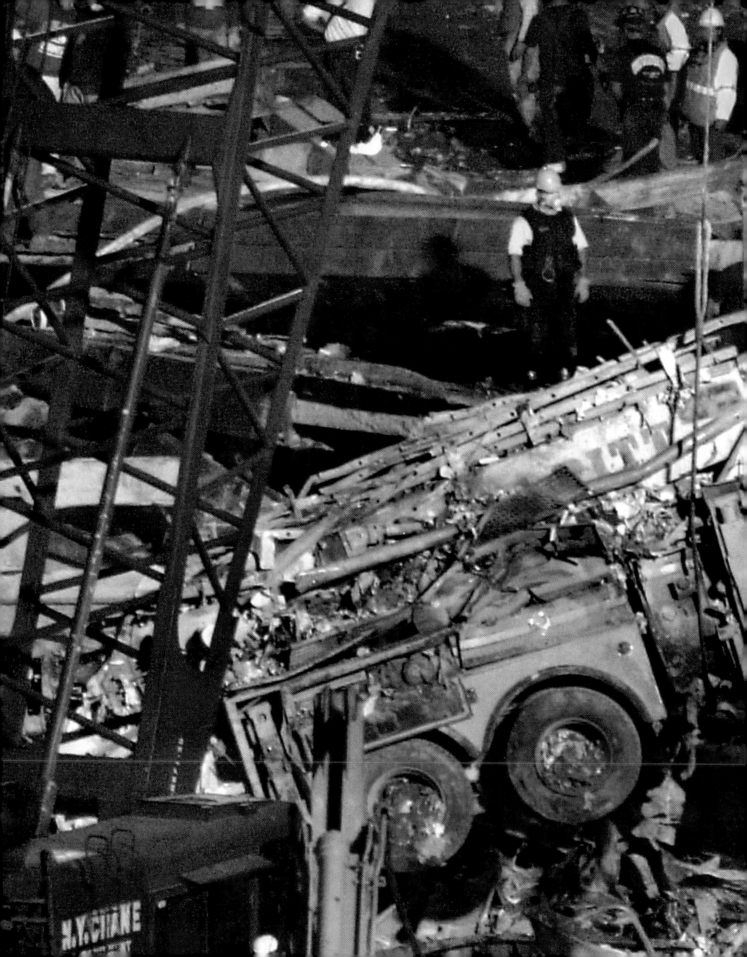

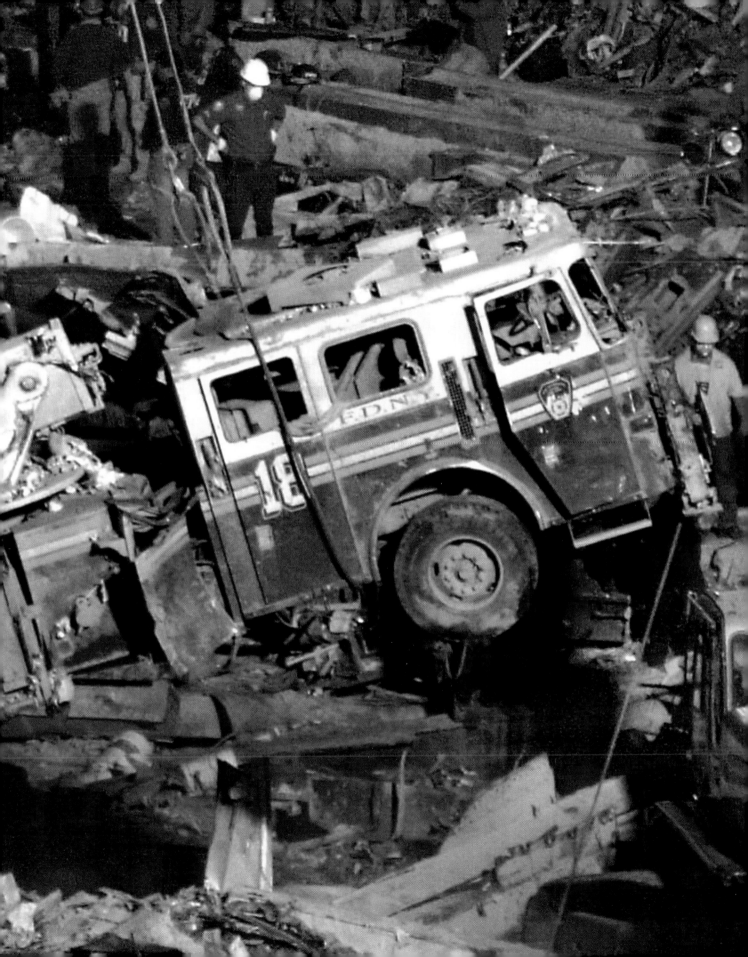

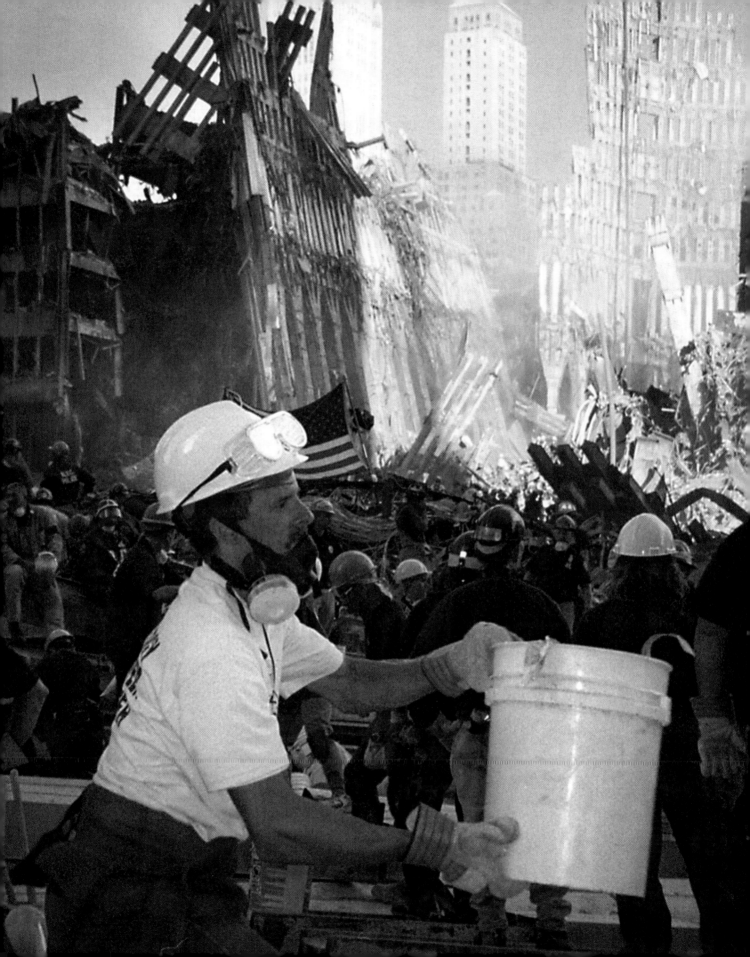

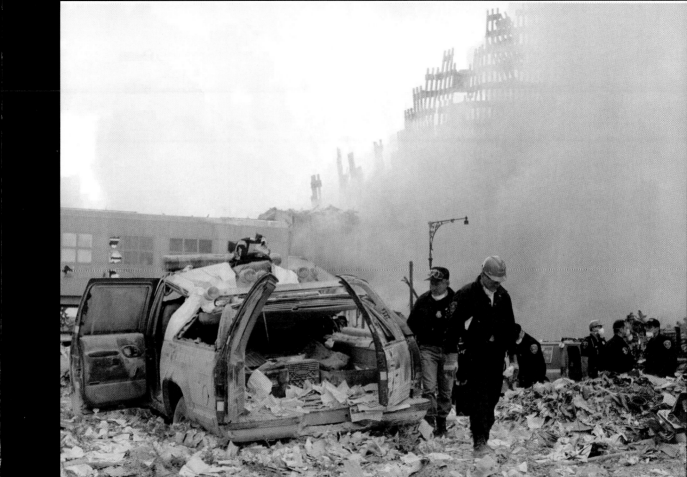

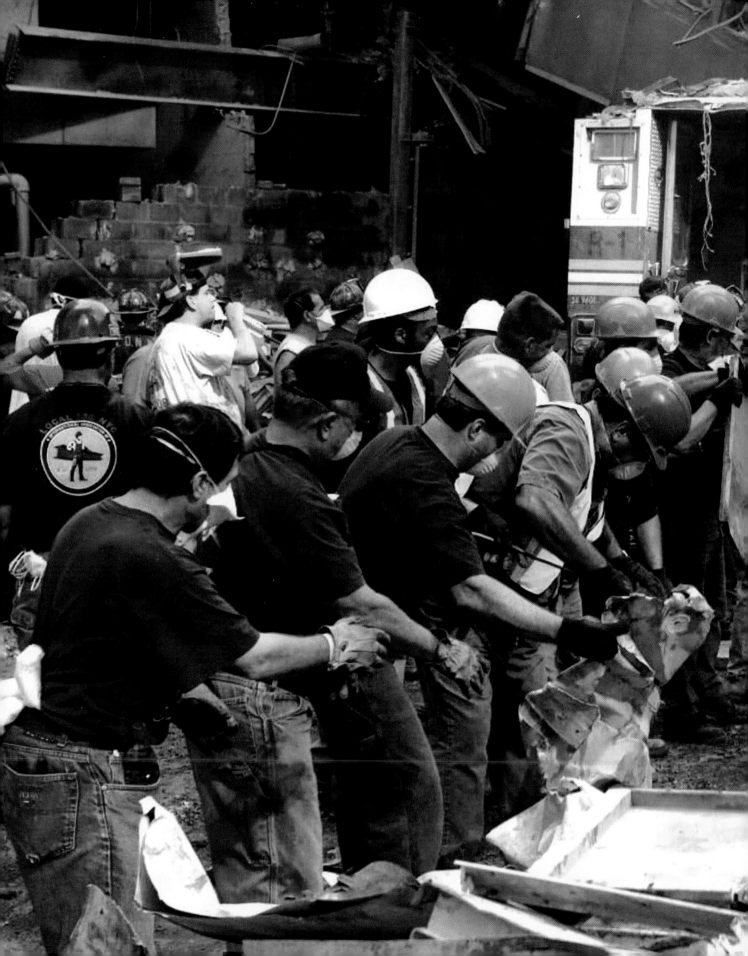

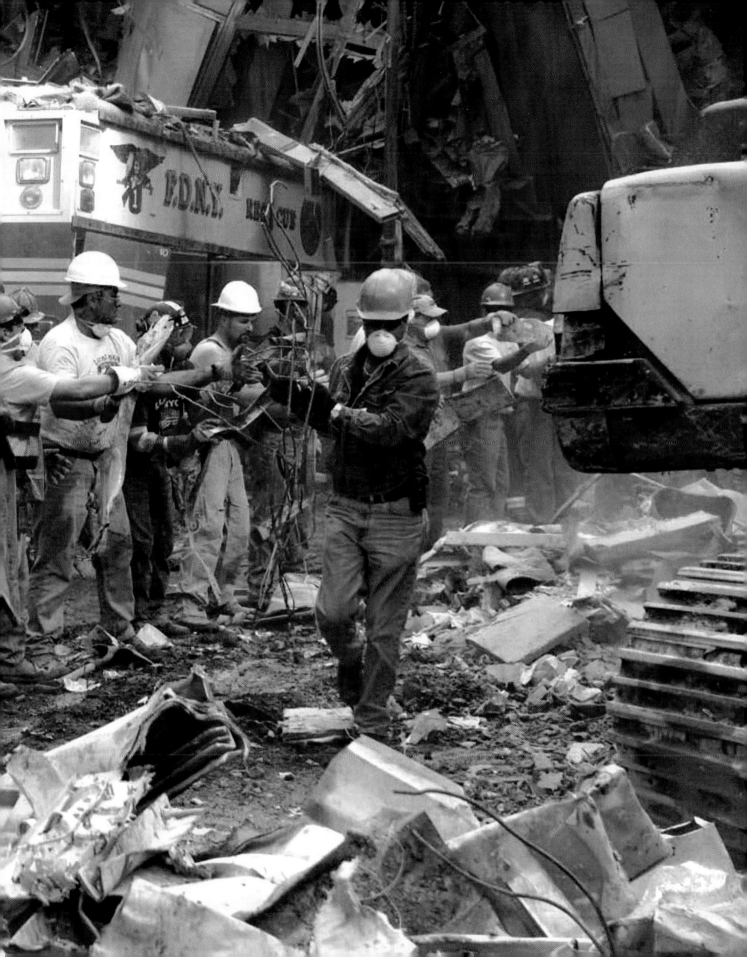

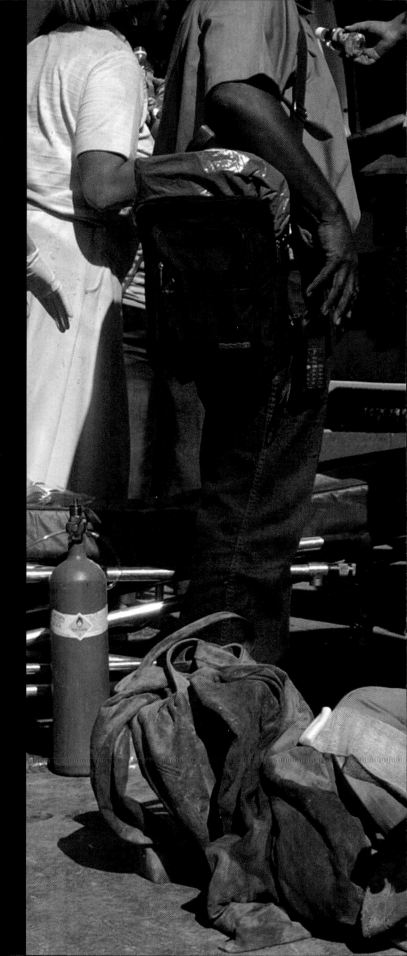

I believe that man will not merely endure. He will prevail. He is immortal, not because he alone among creatures has an inexhaustible voice, but because he has a soul, a spirit capable of compassion and sacrifice and endurance.

—William Faulkner

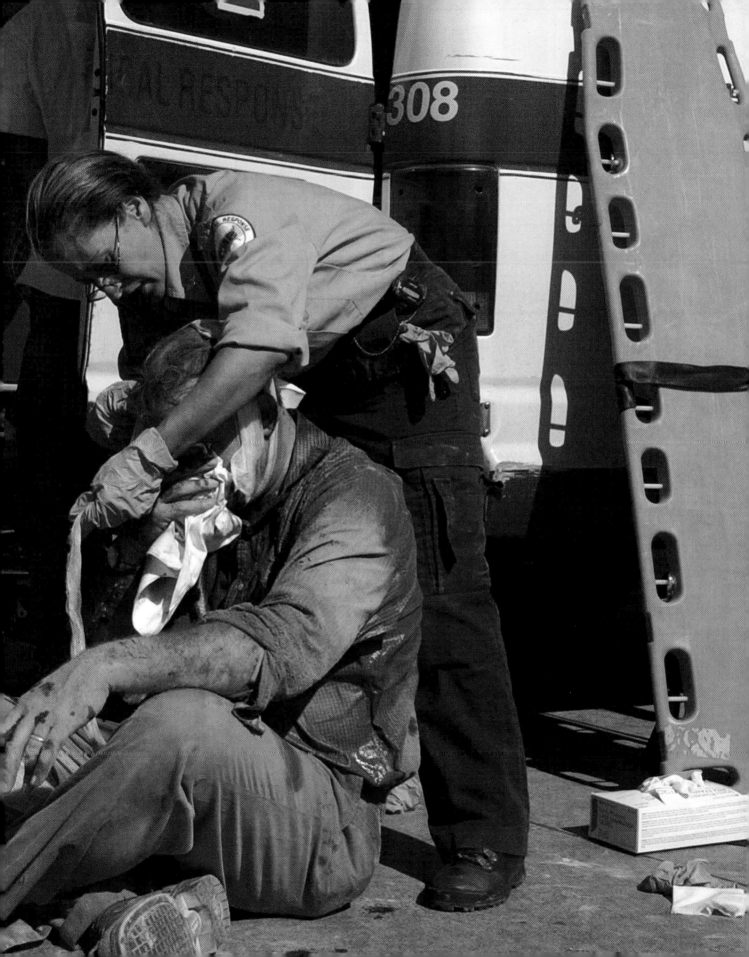

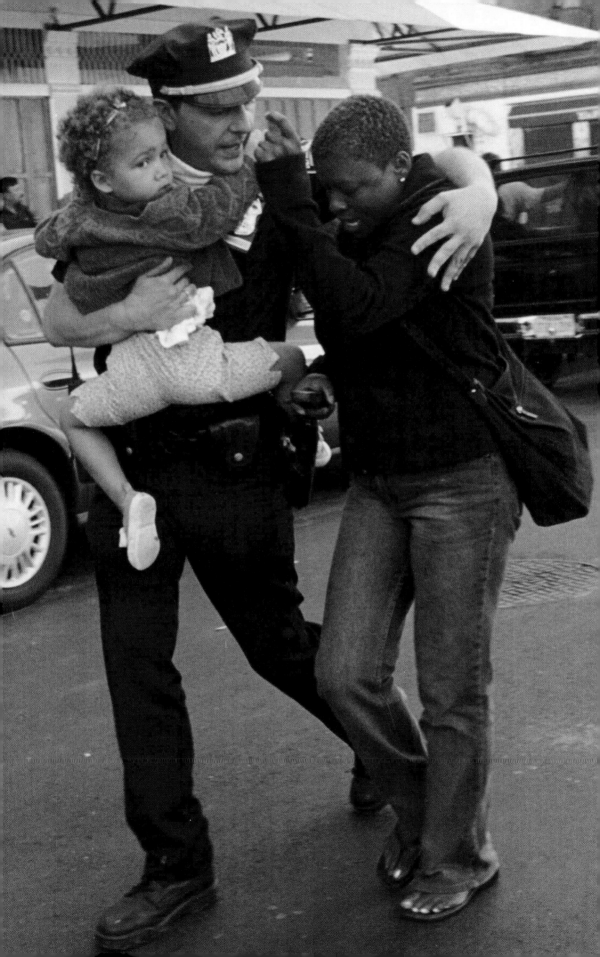

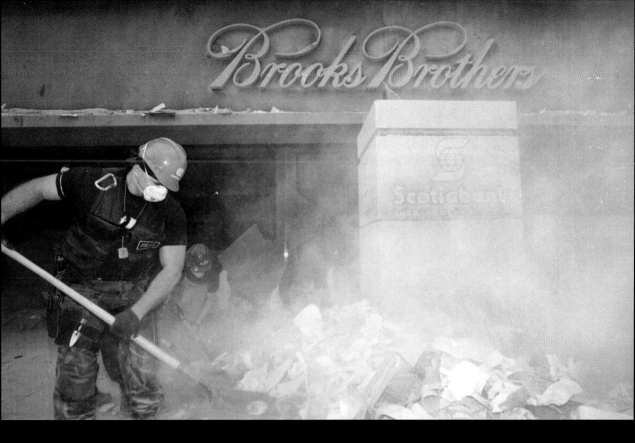

Whatever strength I have comes from the people of New York. They're the remarkable ones. The ones who are lost, the ones who are missing and the ones who are working so hard to find people and bring us all together.

REMEMBER

If you are able

Save for them a place

Inside of you

And save one backward glance

When you are leaving

For the places they can

No longer go.

Be not ashamed to say

You loved them

Though you may

Or may not have always.

And in that time

When men decide and feel safe

To call the war insane,

Take one moment to embrace

Those gentle heroes

You left behind.

—Maj. Michael Davis O'Donnell, January 1, 1970, Dak To Republic of South Vietnam. Major O'Donnell was listed as MIA while piloting a helicopter in Cambodia on March 24, 1970, and as Killed in Action in 1978.

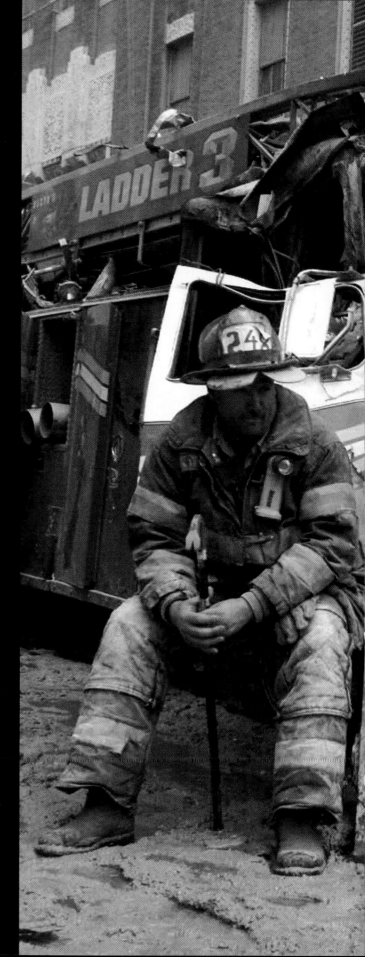

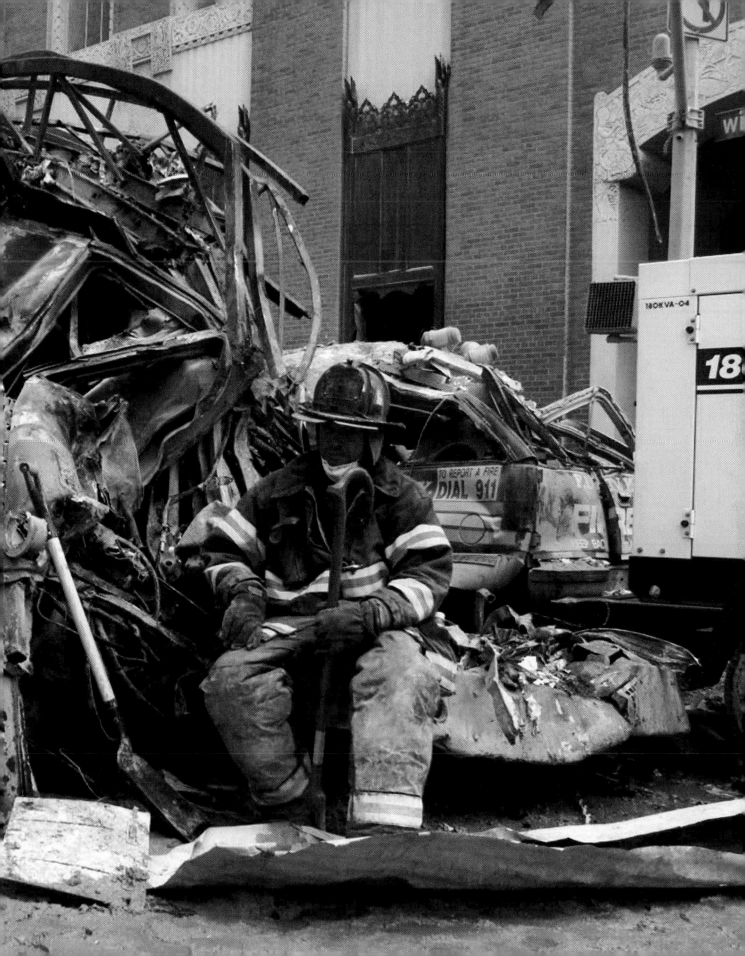

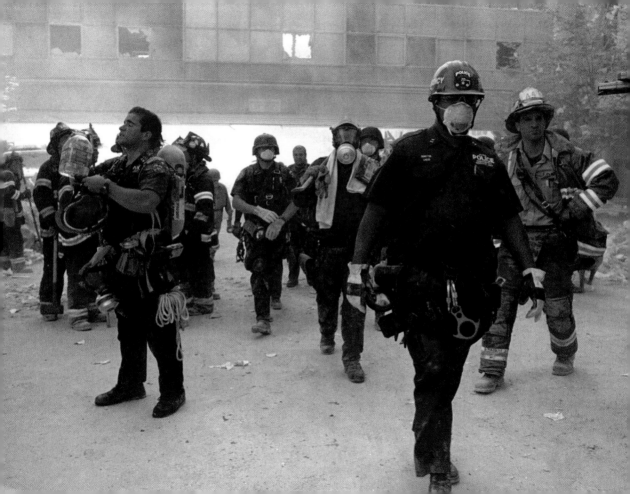

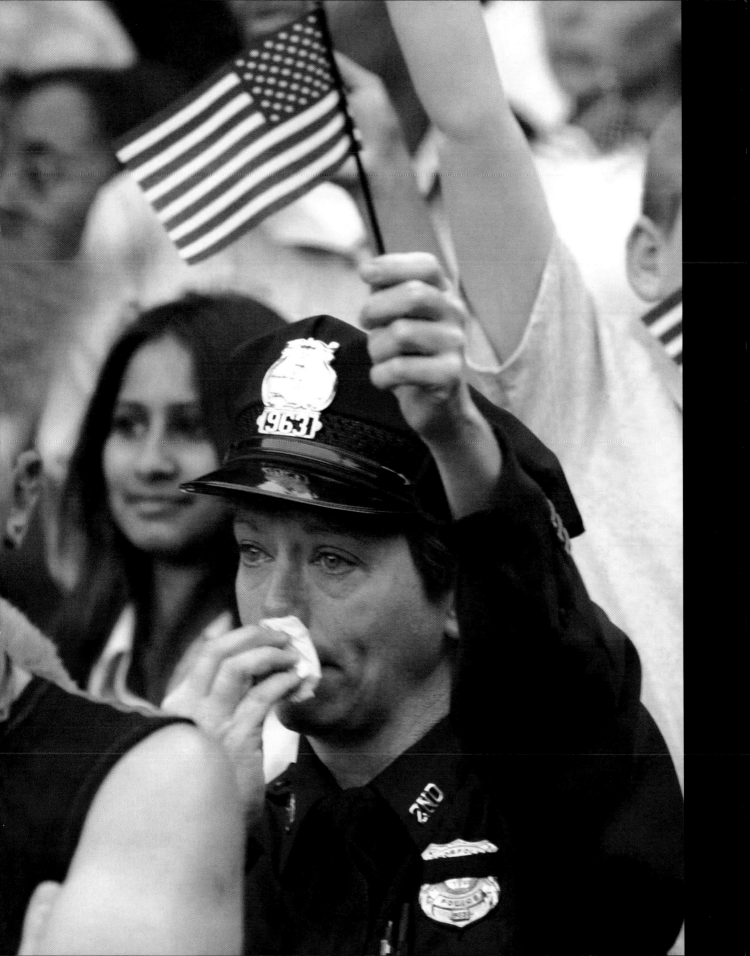

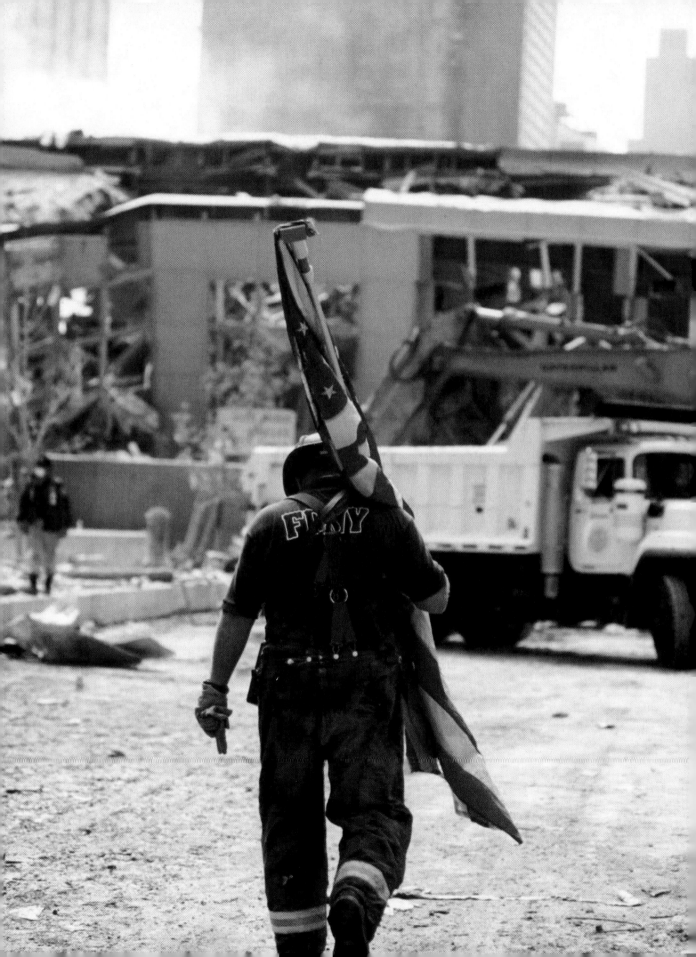

They were of the select few . . .

whose hearts have watched while

their senses slept; whose souls

have grown up into a higher

being; whose pleasure is to be

useful . . . who respire the breath

of honorable fame; who have

deliberately and consciously put

what is called life to hazard,

that they may live in the hearts

of those who come after. Such

men do not, can not die.

—Edward Everett (1794–1865)

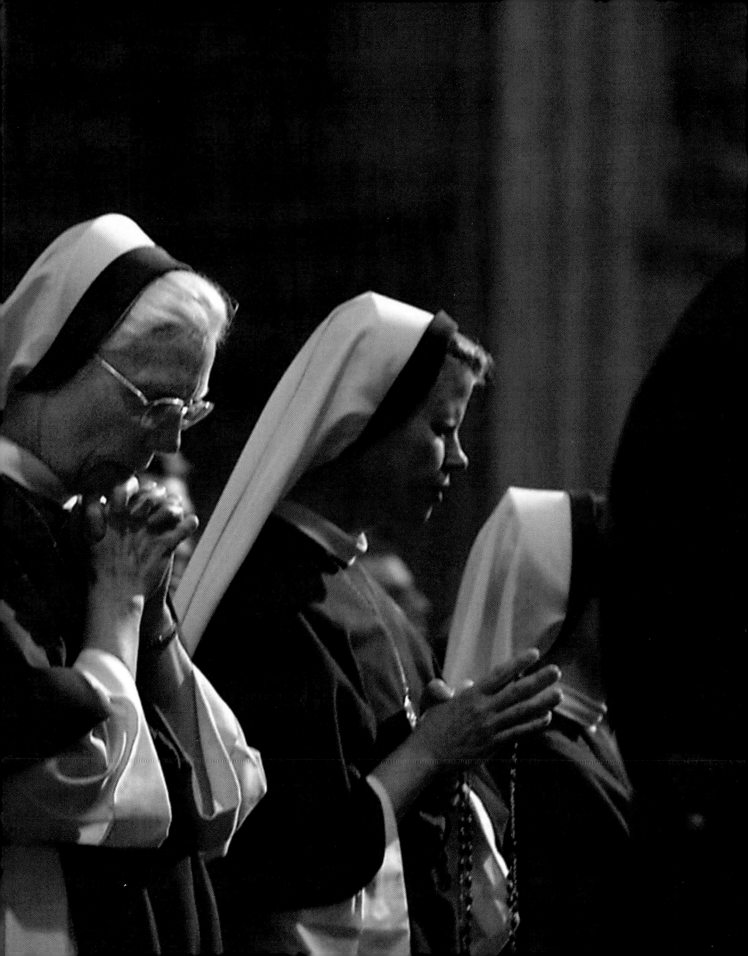

Death, the venerable crucifix in the chapel on the road to Assisi proclaims, has and must have two faces—one of sadness and pain and the other of peace and triumph. The emergency workers guided us, protected us, and gave their lives for us. . . . If this is not triumph, I do not know what triumph might be.

—Edward Cardinal Egan,
September 17, 2001

THE MONUMENT

I never dreamed it would be me
My name for all eternity
Recorded here at this hallowed place
Alas, my name, no more my face.

"In the Line of Duty" I hear them say
My family now the price will pay
My folded flag stained with their tears
We only had those few short years.

The badge no longer on my chest
I sleep now in eternal rest
My sword I pass to those behind
And pray they keep this thought in mind.

I never dreamed it would be me
And with heavy heart and bended knee
I ask for all here from the past
Dear God, let my name be the last.

—Sgt. George Hann, LAPD (ret.)

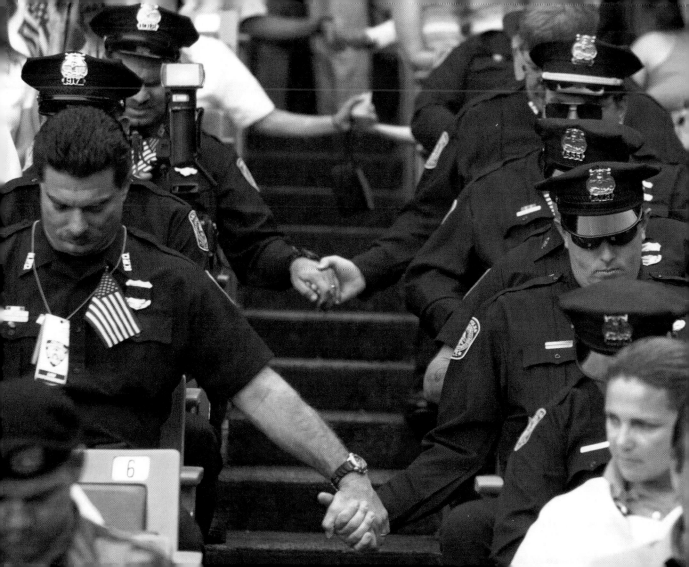

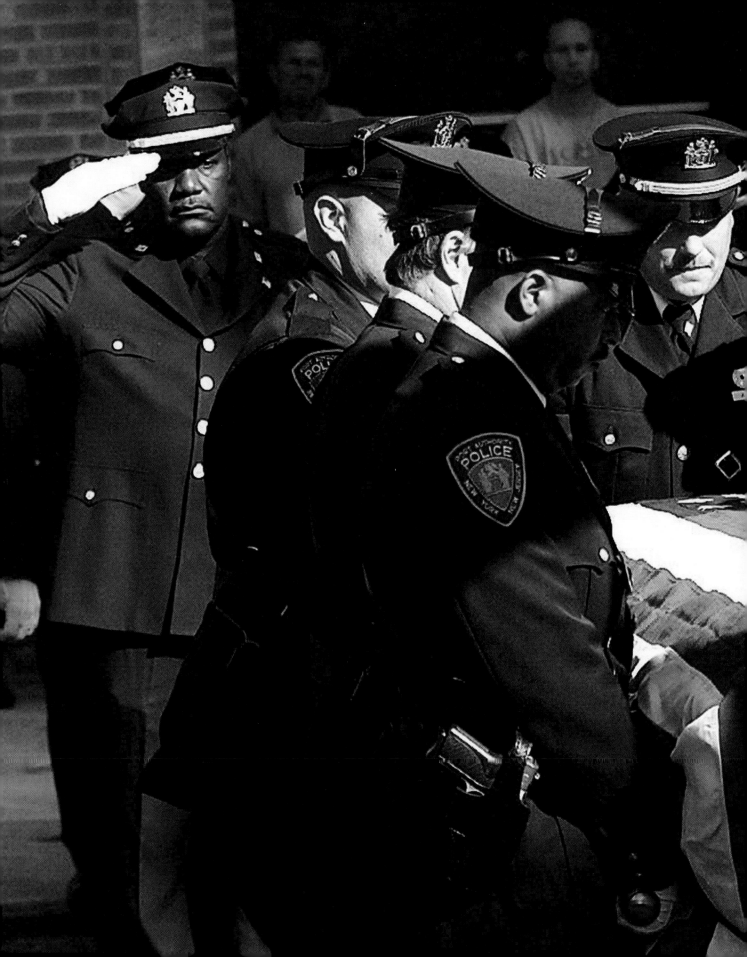

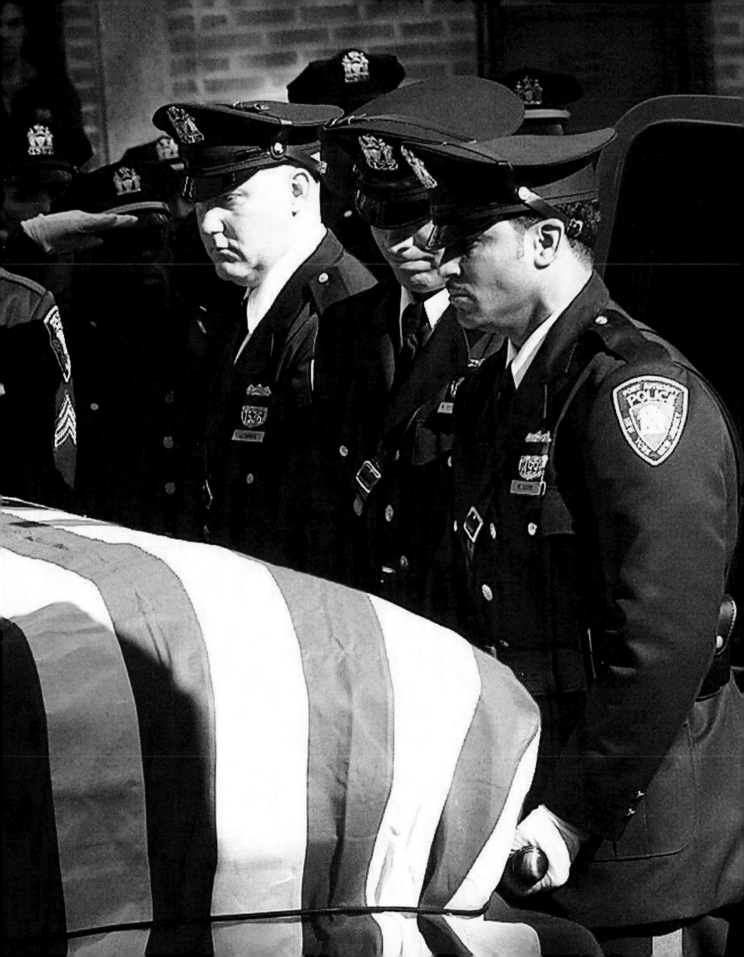

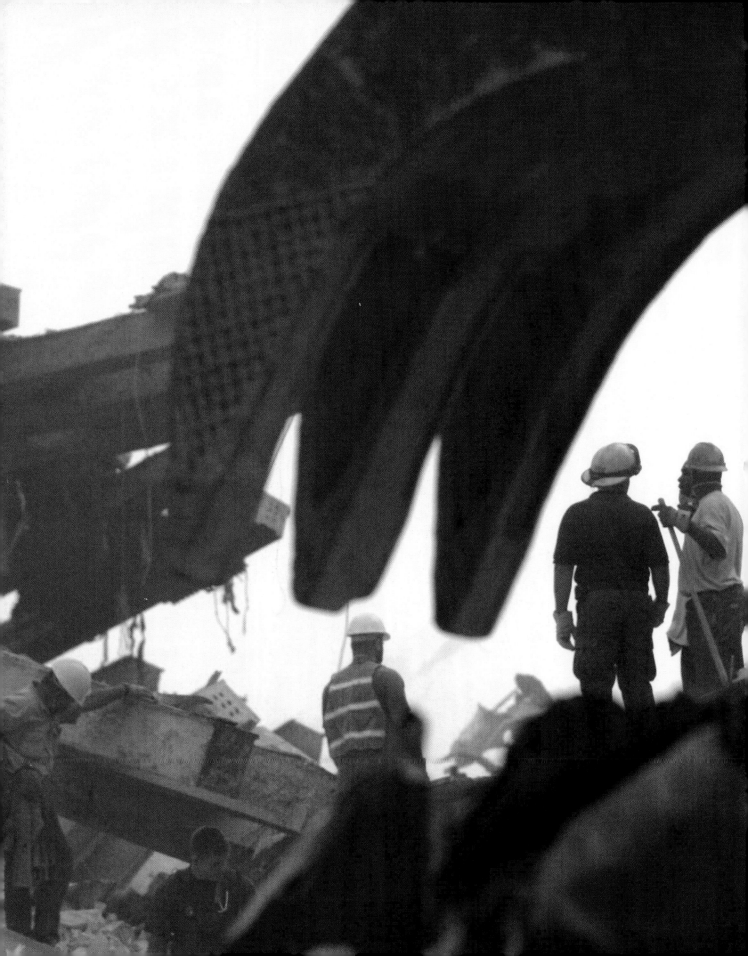

But clouds always pass. The sun always breaks through. And we know as Americans that God's light will again shine across this great land, and that our free and strong people will prevail.

— Governor George E. Pataki,
September 13, 2001

111

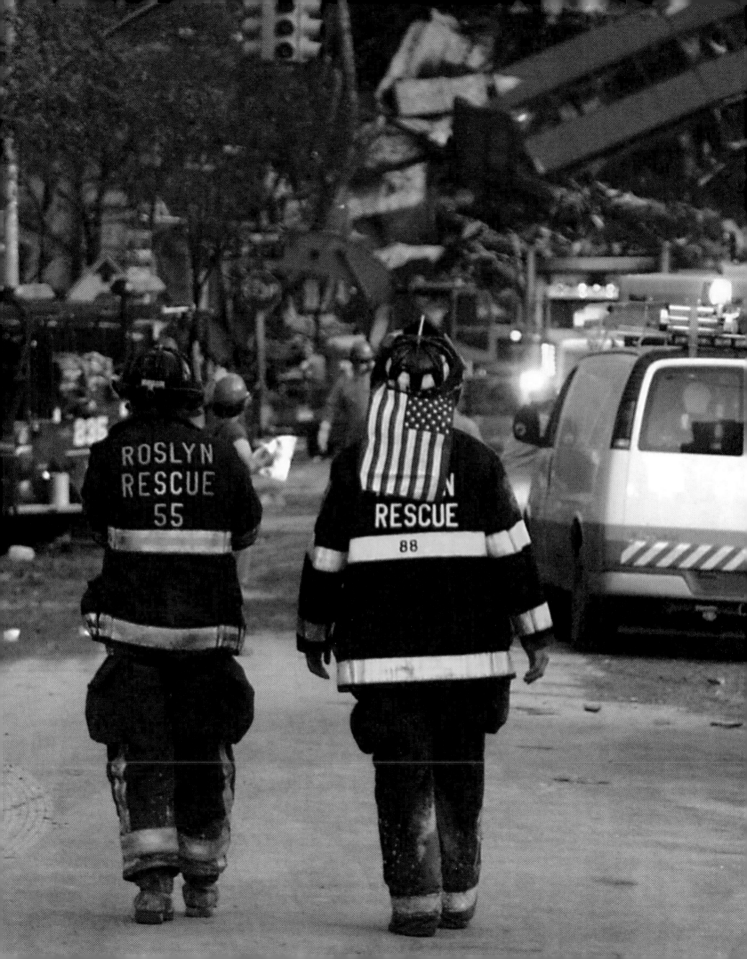

For those to whom much is given, much is required. And when at some future date the high court of history sits in judgment on each of us, recording whether in our brief span of service we fulfilled our responsibilities to the state, our success or failure, in whatever office we hold, will be measured by the answers to four questions: First, were we truly men of courage . . . Second, were we truly men of judgment . . . Third, were we truly men of integrity . . . Finally, were we truly men of dedication?

—John F. Kennedy

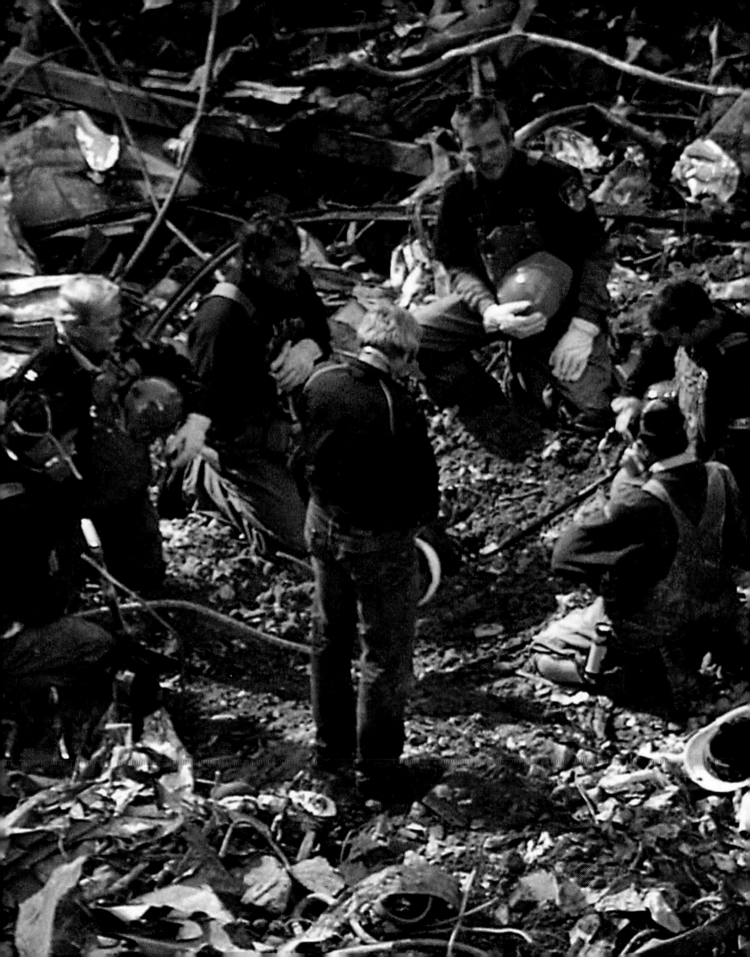

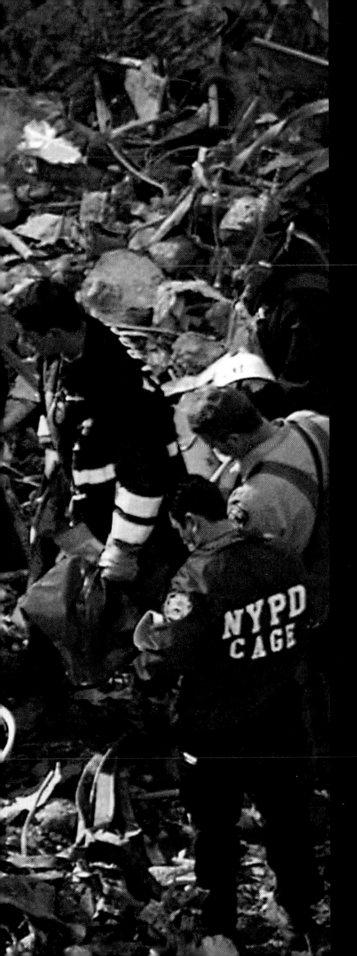

*Remember that this greatness
was won by men with courage,
with knowledge of their duty, and
with a sense of honor in action. . . .
They gave their bodies to the
commonwealth and received, each
for his own memory, praise that
will never die, and with it the
grandest of all sepulchers, not
that in which their mortal bones
are laid, but a home in the minds
of men.*

—Thucydides

*With malice toward none; with
charity for all; with firmness in the
right, as God gives us to see the
right, let us strive on to finish the
work we are in; to bind up the
nation's wounds; to care for him who
shall have borne the battle, and for
his widow, and his orphan—to do
all which may achieve and cherish a
just, and a lasting peace, among
ourselves, and with all nations.*

—Abraham Lincoln

Each of us will remember what happened that day and to whom it happened. We will remember the moment the news came, where we were and what we were doing. Some will remember an image of a fire or story of rescue. Some will carry memories of a face and a voice gone forever.

And I will carry this. It is the police shield of a man named George Howard, who died at the World Trade Center trying to save others. It was given to me by his mom, Arlene, as a proud memorial to her son. It is my reminder of lives that ended and a task that does not end.

—President George W. Bush,
September 20, 2001

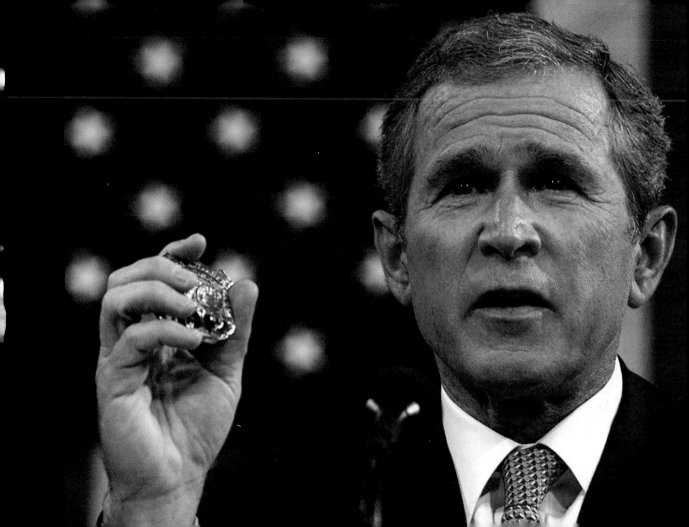

The symbol of red, white and blue

stands for something that can

never be destroyed, even by the most

evil act we can imagine. We are

saddened, [but] we are not devastated.

Death, destruction and evil will never

be the final judgment of a God who

loves us so deeply.

— Monsignor John Ferry,
St. Patrick's Cathedral,
New York City,
September 14, 2001

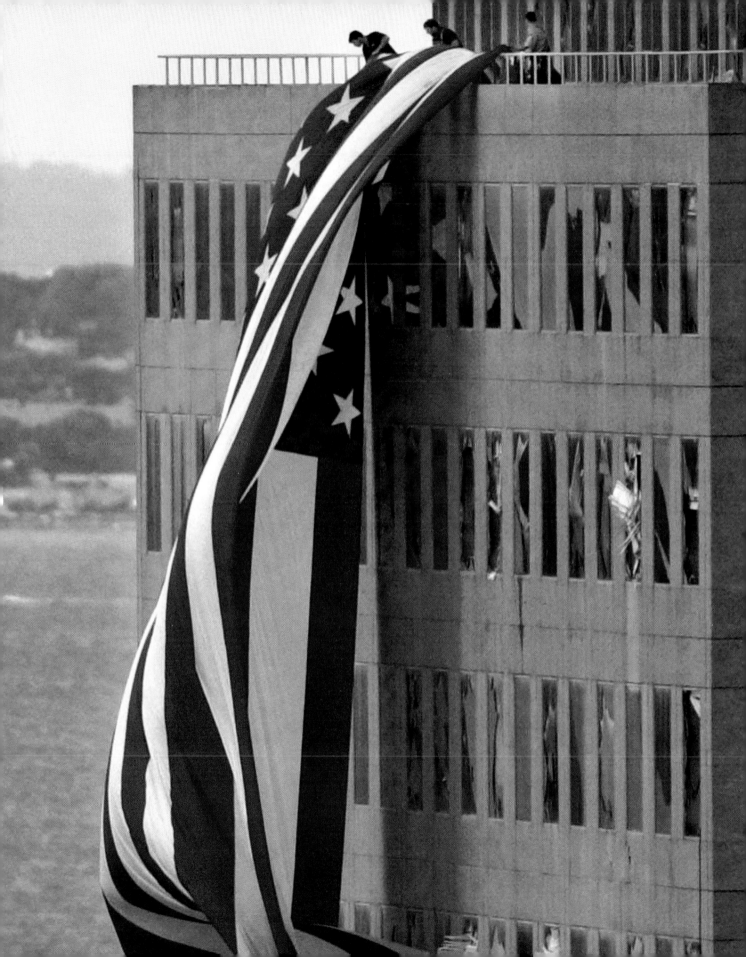

Humanity will not be cast down.
We are going on—swinging
bravely forward—along the grand
high road—and already behind
the distant mountains is the
promise of the sun.

—Winston Churchill

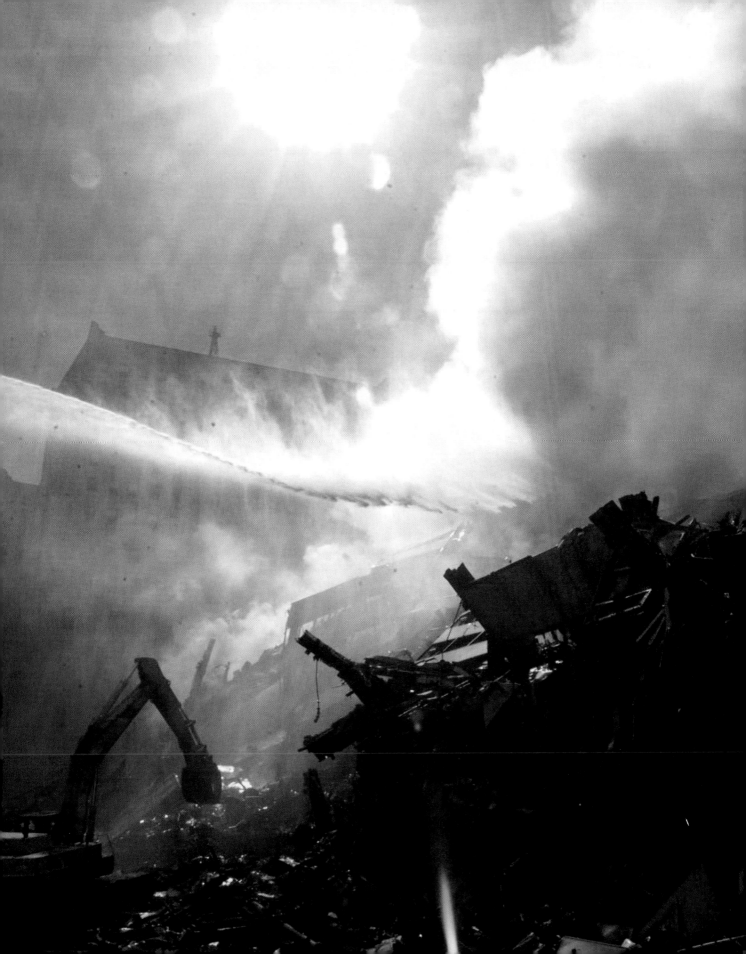

In remembrance

NYPD

JOHN COUGHLIN
Sergeant, ESS #4

MICHAEL CURTIN
Sergeant, ESS #2

JOHN D'ALLARA
Police Officer, ESS #2

VINCENT DANZ
Police Officer, ESS #3

JEROME DOMINGUEZ
Police Officer, ESS #3

STEPHEN DRISCOLL
Police Officer, ESS #4

MARK ELLIS
Police Officer, TD #4

ROBERT FAZIO
Police Officer, 13th Precinct

RODNEY GILLIS
Sergeant, ESS #8

RONALD KLOEPFER
Police Officer, ESS #7

THOMAS LANGONE
Police Officer, ESS #10

JAMES LEAHY
Police Officer, 6th Precinct

BRIAN McDONNELL
Police Officer, ESS #1

JOHN PERRY
Police Officer, 40th Precinct

GLEN PETTIT
Police Officer, Video Unit

CLAUDE RICHARDS
Detective, Bomb Squad

TIMOTHY ROY
Sergeant, S.T.E.D.

MOIRA SMITH
Police Officer, 13th Precinct

RAMON SUAREZ
Police Officer, TD #4

PAUL TALTY
Police Officer, ESS #10

SANTOS VALENTIN
Police Officer, ESS #7

JOSEPH VIGIANO
Detective, ESS #2

WALTER WEAVER
Police Officer, ESS #3

FDNY

JOSEPH AGNELLO
Firefighter, Ladder 118

BRIAN AHEARN
Lieutenant, Battalion 13

ERIC ALLEN
Firefighter, Squad 18

RICHARD ALLEN
Firefighter, Ladder 15

JAMES AMATO
Captain, Squad 1

CALIXTO ANAYA, JR.
Firefighter, Engine 4

JOSEPH ANGELINI
Firefighter, Rescue 1

JOSEPH ANGELINI, JR.
Firefighter, Ladder 4

FAUSTINO APOSTOL, JR.
Firefighter, Battalion 2

DAVID ARCE
Firefighter, Engine 33

LOUIS ARENA
Firefighter, Ladder 5

CARL ASARO
Firefighter, Battalion 9

GREGG ATLAS
Lieutenant, Engine 10

GERALD ATWOOD
Firefighter, Ladder 21

GERALD BAPTISTE
Firefighter, Ladder 9

GERARD BARBARA
Assistant Chief, Citywide
Tour Commander

MATTHEW BARNES
Firefighter, Ladder 25

ARTHUR BARRY
Firefighter, Ladder 15

STEVEN BATES
Lieutenant, Engine 235

CARL BEDIGIAN
Firefighter, Engine 214

STEPHEN BELSON
Firefighter, Ladder 24

JOHN BERGIN
Firefighter, Rescue 5

PAUL BEYER
Firefighter, Engine 6

PETER BIELFIELD
Firefighter, Ladder 24

BRIAN BILCHER
Firefighter, Squad 1

CARL BINI
Firefighter, Rescue 5

CHRISTOPHER BLACKWELL
Firefighter, Rescue 3

MICHAEL BOCCHINO
Firefighter, Battalion 48

FRANK BONOMO
Firefighter, Engine 230

GARY BOX
Firefighter, Squad 1

MICHAEL BOYLE
Firefighter, Engine 33

KEVIN BRACKEN
Firefighter, Engine 40

MICHAEL BRENNAN
Firefighter, Ladder 4

PETER BRENNAN
Firefighter, Rescue 4

DANIEL BRETHEL
Captain, Ladder 24

PATRICK BROWN
Captain, Ladder 3

ANDREW BRUNN
Firefighter, Ladder 5

VINCENT BRUNTON
Captain, Ladder 105

RONALD BUCCA
Fire Marshal

GREG BUCK
Firefighter, Engine 201

WILLIAM BURKE, JR.
Captain, Engine 21

DONALD BURNS
Assistant Chief, Citywide
Tour Commander

JOHN BURNSIDE
Firefighter, Ladder 20

THOMAS BUTLER
Firefighter, Squad 1

PATRICK BYRNE
Firefighter, Ladder 101

GEORGE CAIN
Firefighter, Ladder 7

SALVATORE CALABRO
Firefighter, Ladder 101

FRANK CALLAHAN
Captain, Ladder 35

MICHAEL CAMMARATA
Firefighter, Ladder 11

BRIAN CANNIZZARO
Firefighter, Ladder 101

DENNIS CAREY
Firefighter, Haz-Mat
Company 1

MICHAEL CARLO
Firefighter, Engine 230

MICHAEL CARROLL
Firefighter, Ladder 3

PETER CARROLL
Firefighter, Squad 1

THOMAS CASORIA
Firefighter, Engine 22

MICHAEL CAWLEY
Firefighter, Ladder 136

VERNON CHERRY
Firefighter, Ladder 118

NICHOLAS CHIOFALO
Firefighter, Engine 235

JOHN CHIPURA
Firefighter, Engine 219

MICHAEL CLARKE
Firefighter, Ladder 2

STEVEN COAKLEY
Firefighter, Engine 217

TAREL COLEMAN
Firefighter, Squad 252

JOHN COLLINS
Firefighter, Ladder 25

ROBERT CORDICE
Firefighter, Squad 1

RUBEN CORREA
Firefighter, Engine 74

JAMES J. CORRIGAN
Captain (Retired),
Engine 320

JAMES COYLE
Firefighter, Ladder 3

ROBERT CRAWFORD
Firefighter, Safety Battalion 1

JOHN CRISCI
Lieutenant, Haz-Mat
Company 1

DENNIS CROSS
Battalion Chief, Battalion 57

THOMAS CULLEN III
Firefighter, Squad 41

ROBERT CURATOLO
Firefighter, Ladder 16

EDWARD DATRI
Lieutenant, Squad 1

MICHAEL DAURIA
Firefighter, Engine 40

SCOTT DAVIDSON
Firefighter, Ladder 118

EDWARD DAY
Firefighter, Ladder 11

THOMAS DeANGELIS
Battalion Chief, Battalion 8

MANUEL DELVALLE
Firefighter, Engine 5

MARTIN DEMEO
Firefighter, Haz-Mat
Company 1

DAVID DeRUBBIO
Firefighter, Engine 226

ANDREW DESPERITO
Lieutenant, Engine 1

DENNIS DEVLIN
Battalion Chief, Battalion 9

GERARD DEWAN
Firefighter, Ladder 3

GEORGE DiPASQUALE
Firefighter, Ladder 2

KEVIN DONNELLY
Lieutenant, Ladder 3

KEVIN DOWDELL
Lieutenant, Rescue 4

RAYMOND DOWNEY
Battalion Chief,
Special Operations

GERARD DUFFY
Firefighter, Ladder 21

MARTIN EGAN, JR.
Captain, Division 15

MICHAEL ELFERIS
Firefighter, Engine 22

FRANCIS ESPOSITO
Firefighter, Engine 235

MICHAEL ESPOSITO
Lieutenant, Squad 1

ROBERT EVANS
Firefighter, Engine 33

JOHN FANNING
Battalion Chief,
Haz-Mat Operations

THOMAS FARINO
Captain, Engine 26

TERRENCE FARRELL
Firefighter, Rescue 4

JOSEPH FARRELLY
Captain, Division 1

LEE FEHLING
Firefighter, Engine 235

ALAN FEINBERG
Firefighter, Battalion 9

MICHAEL FIORE
Firefighter, Rescue 5

JOHN FISCHER
Lieutenant, Ladder 20

ANDRE FLETCHER
Firefighter, Rescue 5

JOHN FLORIO
Firefighter, Engine 214

MICHAEL FODOR
Lieutenant, Ladder 21

THOMAS FOLEY
Firefighter, Rescue 3

DAVID FONTANA
Firefighter, Squad 1

ROBERT FOTI
Firefighter, Ladder 7

ANDREW FREDERICKS
Firefighter, Squad 18

PETER FREUND
Lieutenant, Engine 55

THOMAS GAMBINO, JR.
Firefighter, Rescue 3

PETER J. GANCI, JR.
Chief of Department

CHARLES GARBARINI
Lieutenant, Battalion 9

THOMAS GARDNER
Firefighter, Haz-Mat
Company 1

MATTHEW GARVEY
Firefighter, Squad 1

BRUCE GARY
Firefighter, Engine 40

GARY GEIDEL
Firefighter, Rescue 1

EDWARD GERAGHTY
Battalion Chief,
Battalion 9

DENIS GERMAIN
Firefighter, Ladder 2

VINCENT GIAMMONA
Lieutenant, Ladder 5

JAMES GIBERSON
Firefighter, Ladder 35

RONNIE GIES
Firefighter, Squad 288

PAUL GILL
Firefighter, Engine 54

JOHN GINLEY
Lieutenant, Engine 40

JEFFREY GIORDANO
Firefighter, Ladder 3

JOHN GIORDANO
Firefighter, Engine 37

KEITH GLASCOE
Firefighter, Ladder 21

JAMES GRAY
Firefighter, Ladder 20

JOSEPH GRZELAK
Battalion Chief,
Battalion 48

JOSE GUADALUPE
Firefighter, Engine 54

GEOFFREY GUJA
Lieutenant, Battalion 43

JOSEPH GULLICKSON
Lieutenant, Ladder 101

DAVID HALDERMAN
Firefighter, Squad 18

VINCENT HALLORAN
Lieutenant, Ladder 8

ROBERT HAMILTON
Firefighter, Squad 41

SEAN HANLEY
Firefighter, Ladder 20

THOMAS HANNAFIN
Firefighter, Ladder 5

DANA HANNON
Firefighter, Engine 26

DANIEL HARLIN
Firefighter, Ladder 2

HARVEY HARRELL
Lieutenant, Rescue 5

STEPHEN HARRELL
Lieutenant, Battalion 7

THOMAS HASKELL, JR.
Captain, Division 15

TIMOTHY HASKELL
Firefighter, Squad 18

TERENCE HATTON
Captain, Rescue 1

MICHAEL HAUB
Firefighter, Ladder 4

PHILIP T. HAYES
Firefighter (Retired),
Engine 217

MICHAEL HEALEY
Lieutenant, Squad 41

JOHN HEFFERNAN
Firefighter, Ladder 11

RONNIE HENDERSON
Firefighter, Engine 279

JOSEPH HENRY
Firefighter, Ladder 21

WILLIAM HENRY
Firefighter, Rescue 1

THOMAS HETZEL
Firefighter, Ladder 13

BRIAN HICKEY
Captain, Rescue 4

TIMOTHY HIGGINS
Lieutenant, Special
Operations

JONATHAN HOHMANN
Firefighter, Haz-Mat
Company 1

THOMAS HOLOHAN
Firefighter, Engine 6

JOSEPH HUNTER
Firefighter, Squad 288

WALTER HYNES
Captain, Ladder 13

JONATHAN IELPI
Firefighter, Squad 288

FREDERICK ILL, JR.
Captain, Ladder 2

WILLIAM JOHNSTON
Firefighter, Engine 6

ANDREW JORDAN
Firefighter, Ladder 132

KARL JOSEPH
Firefighter, Engine 207

ANTHONY JOVIC
Lieutenant, Battalion 47

ANGEL JUARBE, JR.
Firefighter, Ladder 12

MYCHAL JUDGE
Chaplain

VINCENT KANE
Firefighter, Engine 22

CHARLES KASPER
Battalion Chief,
SOC Battalion

PAUL KEATING
Firefighter, Ladder 5

THOMAS KELLY
Firefighter, Ladder 15

THOMAS KELLY
Firefighter, Ladder 105

RICHARD KELLY, JR.
Firefighter, Ladder 11

THOMAS KENNEDY
Firefighter, Ladder 101

RONALD KERWIN
Lieutenant, Squad 288

MICHAEL KIEFER
Firefighter, Ladder 132

ROBERT KING, JR.
Firefighter, Engine 33

SCOTT KOPYTKO
Firefighter, Ladder 15

WILLIAM KRUKOWSKI
Firefighter, Ladder 21

KENNETH KUMPEL
Firefighter, Ladder 25

THOMAS KUVEIKIS
Firefighter, Squad 252

DAVID LaFORGE
Firefighter, Ladder 20

WILLIAM LAKE
Firefighter, Rescue 2

ROBERT LANE
Firefighter, Engine 55

PETER LANGONE
Firefighter, Squad 252

SCOTT LARSEN
Firefighter, Ladder 15

JOSEPH LEAVEY
Lieutenant, Ladder 15

NEIL LEAVY
Firefighter, Engine 217

DANIEL LIBRETTI
Firefighter, Rescue 2

CARLOS LILLO
Paramedic, Battalion 49

ROBERT LINNANE
Firefighter, Ladder 20

MICHAEL LYNCH
Firefighter, Engine 40

MICHAEL LYNCH
Firefighter, Ladder 4

MICHAEL LYONS
Firefighter, Squad 41

PATRICK LYONS
Firefighter, Squad 252

JOSEPH MAFFEO
Firefighter, Ladder 101

WILLIAM MAHONEY
Firefighter, Rescue 4

JOSEPH MALONEY
Firefighter, Ladder 3

JOSEPH MARCHBANKS, JR.
Battalion Chief, Battalion 57

CHARLES MARGIOTTA
Lieutenant, Battalion 22

KENNETH MARINO
Firefighter, Rescue 1

JOHN MARSHALL
Firefighter, Ladder 27

JOSEPH MASCALI
Firefighter, Tactical Support 2

PETER MARTIN
Lieutenant, Rescue 2

PAUL MARTINI
Lieutenant, Engine 201

KEITHROY MAYNARD
Firefighter, Engine 33

BRIAN McALEESE
Firefighter, Engine 226

JOHN McAVOY
Firefighter, Ladder 3

THOMAS McCANN
Firefighter, Battalion 8

WILLIAM McGINN
Lieutenant, Squad 18

WILLIAM McGOVERN
Battalion Chief,
Battalion 2

DENNIS McHUGH
Firefighter, Ladder 13

ROBERT McMAHON
Firefighter, Ladder 20

ROBERT McPADDEN
Firefighter, Engine 23

TERENCE McSHANE
Firefighter, Ladder 101

TIMOTHY McSWEENEY
Firefighter, Ladder 3

MARTIN McWILLIAMS
Firefighter, Engine 22

RAYMOND MEISENHEIMER
Firefighter, Rescue 3

CHARLES MENDEZ
Firefighter, Ladder 7

STEVE MERCADO
Firefighter, Engine 40

DOUGLAS MILLER
Firefighter, Rescue 5

HENRY MILLER, JR.
Firefighter, Ladder 105

ROBERT MINARA
Firefighter, Ladder 25

THOMAS MINGIONE
Firefighter, Ladder 132

PAUL MITCHELL
Lieutenant, Battalion 1

LOUIS MODAFFERI
Captain, Rescue 5

DENNIS MOJICA
Lieutenant, Rescue 1

MANUEL MOJICA
Firefighter, Squad 18

CARL MOLINARO
Firefighter, Ladder 2

MICHAEL MONTESI
Firefighter, Rescue 1

THOMAS MOODY
Captain, Division 1

JOHN MORAN
Battalion Chief,
Battalion 49

VINCENT MORELLO
Firefighter, Ladder 35

CHRISTOPHER MOZZILLO
Firefighter, Engine 55

RICHARD MULDOWNEY, JR.
Firefighter, Ladder 7

MICHAEL MULLAN
Firefighter, Ladder 12

DENNIS MULLIGAN
Firefighter, Ladder 2

RAYMOND MURPHY
Lieutenant, Ladder 16

ROBERT NAGEL
Lieutenant, Engine 58

JOHN NAPOLITANO
Firefighter, Rescue 2

PETER NELSON
Firefighter, Rescue 4

GERARD NEVINS
Firefighter, Rescue 1

DENNIS OBERG
Firefighter, Ladder 105

DANIEL O'CALLAGHAN
Lieutenant, Ladder 4

DOUGLAS OELSCHLAGER
Firefighter, Ladder 15

JOSEPH OGREN
Firefighter, Ladder 3

THOMAS O'HAGAN
Lieutenant, Battalion 4

SAMUEL OITICE
Firefighter, Ladder 4

PATRICK O'KEEFE
Firefighter, Rescue 1